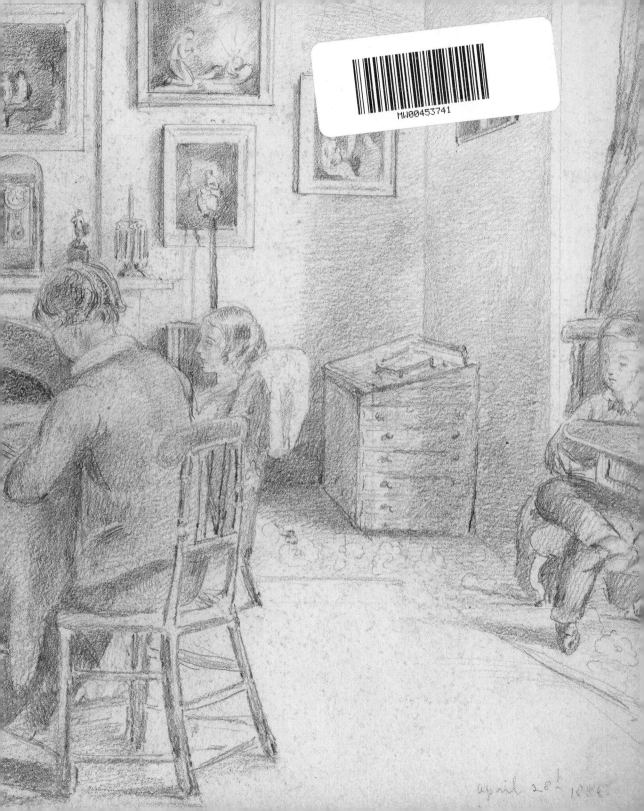

april 20th 1866

GAILEARAÍ NÁISIÚNTA na hÉIREANN

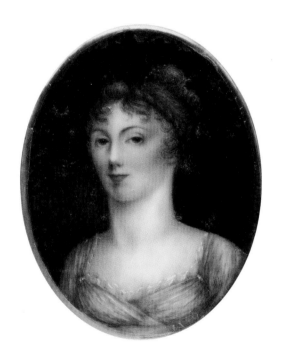

NATIONAL GALLERY of IRELAND

DIARY 2023

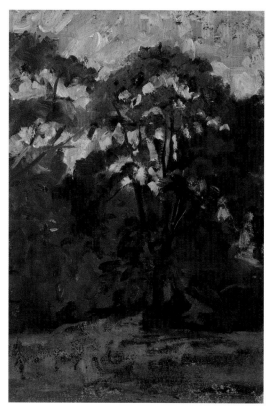

TITLE PAGE Elizabeth McCausland, *Charlotte Edgeworth,* **1807**

Charlotte Edgeworth was the fifth daughter of author and inventor Richard Lovell Edgeworth, and half-sister of novelist Maria Edgeworth. Charlotte died at the age of twenty-four at her home in Edgeworthstown, County Longford. This miniature in watercolour on ivory dates from the year of her death and may be a posthumous portrait created by an artist who was an acquaintance of the family. Charlotte appears as an intelligent young woman of strong character. Nothing is known of McCausland, but her style, based on this portrait, was fine and delicate but with a stiffness of pose suggesting that she was perhaps self-taught.

THIS PAGE Clare Marsh, *Sketch of Trees,* **20th century**

Marsh studied at the Metropolitan School of Art in Dublin, under John Butler Yeats at Miss Manning's studio, and in Penzance with Norman Garstin. Yeats urged her to sketch and they became lifelong friends. In 1916 Marsh was appointed Professor of Fine Art at Alexandra College, Dublin. She painted portraits, landscapes, genre scenes and flowers, gradually leaning towards Post-Impressionism, her style an interesting blend of academic and modernist influences. Another close friend was Mary Swanzy, with whom she shared a studio from 1920. They held a joint exhibition prior to Marsh's premature death in 1923 at the age of forty-eight.

FRONT COVER Lavinia Fontana, *Isabella Ruini as Venus,* **1592** (Musée des Beaux-Arts, Rouen)

BACK COVER Mainie Jellett, *Abstract,* **1932**

ENDPAPERS Louisa Taylor, *The Taylor Family in their Living Room, Hung with Paintings,* **1858**

GAILEARAÍ NÁISIÚNTA na hÉIREANN NATIONAL GALLERY of IRELAND

www.nationalgallery.ie
Twitter @NGIreland
Facebook.com/nationalgalleryofireland

Gill Books
Hume Avenue, Park West, Dublin 12
www.gillbooks.ie

Gill Books is an imprint of M.H. Gill & Co.

© The National Gallery of Ireland 2022

9780717195114

Text researched and written by Sara Donaldson/NGI
Design by Tony Potter
Photography by Roy Hewson and Chris O'Toole/NGI

Print origination by Teapot Press Ltd
Printed in the EU

This book is typeset in Dax

The paper used in this book comes from the wood pulp of sustainably managed forests.

5 4 3 2 1

2023

January • Eanáir
M	T	W	T	F	S	S
26	27	28	29	30	31	1
2	3	4	5	6	7	8
9	10	11	12	13	14	15
16	17	18	19	20	21	22
23	24	25	26	27	28	29
30	31	1	2	3	4	5

February • Feabhra
M	T	W	T	F	S	S
30	31	1	2	3	4	5
6	7	8	9	10	11	12
13	14	15	16	17	18	19
20	21	22	23	24	25	26
27	28	1	2	3	4	5

March • Márta
M	T	W	T	F	S	S
27	28	1	2	3	4	5
6	7	8	9	10	11	12
13	14	15	16	17	18	19
20	21	22	23	24	25	26
27	28	29	30	31	1	2

April • Aibreán
M	T	W	T	F	S	S
27	28	29	30	31	1	2
3	4	5	6	7	8	9
10	11	12	13	14	15	16
17	18	19	20	21	22	23
24	25	26	27	28	29	30

May • Bealtaine
M	T	W	T	F	S	S
1	2	3	4	5	6	7
8	9	10	11	12	13	14
15	16	17	18	19	20	21
22	23	24	25	26	27	28
29	30	31	1	2	3	4

June • Meitheamh
M	T	W	T	F	S	S
29	30	31	1	2	3	4
5	6	7	8	9	10	11
12	13	14	15	16	17	18
19	20	21	22	23	24	25
26	27	28	29	30	1	2

July • Iúil
M	T	W	T	F	S	S
26	27	28	29	30	1	2
3	4	5	6	7	8	9
10	11	12	13	14	15	16
17	18	19	20	21	22	23
24	25	26	27	28	29	30
31	1	2	3	4	5	6

August • Lúnasa
M	T	W	T	F	S	S
31	1	2	3	4	5	6
7	8	9	10	11	12	13
14	15	16	17	18	19	20
21	22	23	24	25	26	27
28	29	30	31	1	2	3

September • Meán Fómhair
M	T	W	T	F	S	S
28	29	30	31	1	2	3
4	5	6	7	8	9	10
11	12	13	14	15	16	17
18	19	20	21	22	23	24
25	26	27	28	29	30	1

October • Deireadh Fómhair
M	T	W	T	F	S	S
25	26	27	28	29	30	1
2	3	4	5	6	7	8
9	10	11	12	13	14	15
16	17	18	19	20	21	22
23	24	25	26	27	28	29
30	31	1	2	3	4	5

November • Samhain
M	T	W	T	F	S	S
30	31	1	2	3	4	5
6	7	8	9	10	11	12
13	14	15	16	17	18	19
20	21	22	23	24	25	26
27	28	29	30	1	2	3

December • Nollaig
M	T	W	T	F	S	S
27	28	29	30	1	2	3
4	5	6	7	8	9	10
11	12	13	14	15	16	17
18	19	20	21	22	23	24
25	26	27	28	29	30	31

2024

January • Eanáir
M	T	W	T	F	S	S
1	2	3	4	5	6	7
8	9	10	11	12	13	14
15	16	17	18	19	20	21
22	23	24	25	26	27	28
29	30	31	1	2	3	4

February • Feabhra
M	T	W	T	F	S	S
29	30	31	1	2	3	4
5	6	7	8	9	10	11
12	13	14	15	16	17	18
19	20	21	22	23	24	25
26	27	28	29	1	2	3

March • Márta
M	T	W	T	F	S	S
26	27	28	29	1	2	3
4	5	6	7	8	9	10
11	12	13	14	15	16	17
18	19	20	21	22	23	24
25	26	27	28	29	30	31

April • Aibreán
M	T	W	T	F	S	S
1	2	3	4	5	6	7
8	9	10	11	12	13	14
15	16	17	18	19	20	21
22	23	24	25	26	27	28
29	30	1	2	3	4	5

May • Bealtaine
M	T	W	T	F	S	S
29	30	1	2	3	4	5
6	7	8	9	10	11	12
13	14	15	16	17	18	19
20	21	22	23	24	25	26
27	28	29	30	31	1	2

June • Meitheamh
M	T	W	T	F	S	S
27	28	29	30	31	1	2
3	4	5	6	7	8	9
10	11	12	13	14	15	16
17	18	19	20	21	22	23
24	25	26	27	28	29	30

July • Iúil
M	T	W	T	F	S	S
1	2	3	4	5	6	7
8	9	10	11	12	13	14
15	16	17	18	19	20	21
22	23	24	25	26	27	28
29	30	31	1	2	3	4

August • Lúnasa
M	T	W	T	F	S	S
29	30	31	1	2	3	4
5	6	7	8	9	10	11
12	13	14	15	16	17	18
19	20	21	22	23	24	25
26	27	28	29	30	31	1

September • Meán Fómhair
M	T	W	T	F	S	S
26	27	28	29	30	31	1
2	3	4	5	6	7	8
9	10	11	12	13	14	15
16	17	18	19	20	21	22
23	24	25	26	27	28	29
30	1	2	3	4	5	6

October • Deireadh Fómhair
M	T	W	T	F	S	S
30	1	2	3	4	5	6
7	8	9	10	11	12	13
14	15	16	17	18	19	20
21	22	23	24	25	26	27
28	29	30	31	1	2	3

November • Samhain
M	T	W	T	F	S	S
28	29	30	31	1	2	3
4	5	6	7	8	9	10
11	12	13	14	15	16	17
18	19	20	21	22	23	24
25	26	27	28	29	30	1

December • Nollaig
M	T	W	T	F	S	S
25	26	27	28	29	30	1
2	3	4	5	6	7	8
9	10	11	12	13	14	15
16	17	18	19	20	21	22
23	24	25	26	27	28	29
30	31	1	2	3	4	5

The National Gallery of Ireland diary for 2023 takes us into new territory, from the home to landscapes we love and admire, as we glide towards more familiar patterns of behaviour and activity in our own daily lives. *The Fisherman's Mother*, on the opposite page, has seen and heard it all before.

Both of our paintings by Lavinia Fontana grace these pages, including the spectacular *Visit of the Queen of Sheba to King Solomon*. This magnificent work forms the centrepiece of our special exhibition during the year. Fontana's presence in the opening pages of the diary is the first highlight of this year's selection of images, which celebrates art made by women. The selection is particularly rich in works of the late 19th and early 20th centuries. Sarah Purser's enigmatic pairing of a woman holding a child's rattle is followed, in late January, by the peaceful slumber of Dod Procter's sleeping girl.

Beyond the intimacy of domestic interiors, we brace ourselves for the open seas in March, with Mainie Jellett's *A Composition – Sea Rhythm*. Mary Swanzy's fiery, allegorical landscape comes into view as we turn the pages and March moves into April. Elizabeth – 'Lolly' – Yeats brings us spring flowers on her exquisite painted fan, as April comes to a close. This hand-painted object, one of many in our Yeats Archive, is testament to the breadth of talent in the Yeats family.

Looking across to France, a firm favourite takes us through to early summer: Eva Gonzalès' charming painting of a brother and sister at Grandcamp resting while lugging a heavy basket full of fish through the dunes. Mildred Anne Butler transports us back to Kilkenny in her exquisitely detailed watercolour of lilac phlox blooms in a mature garden. Gabrielle Münter's Matisse-inspired examination of a young woman has the heightened colours of early-20th-century German expressionism. The contrast between her sombre gaze and the sumptuously dressed nobleman portrayed by Sofonisba Anguissola in 1560, illustrated in the August pages, could not be greater.

Magical animal presences appear in Norah McGuinness' *The Startled Bird,* immediately followed by Rose Bonheur's alert stag, delicately lit in a woodland glade. As the nights draw in, Mildred Anne Butler's *Shades of Evening* prepares us for the cooler months, and we reflect upon Mainie Jellett's *The Virgin and Child Enthroned* during Christmas week. As always, this visual feast in the National Gallery diary accompanies us through the year.

Sean Rainbird, Director, National Gallery of Ireland, 2012–2022

Helen Mabel Trevor, *The Fisherman's Mother,* 1892

In Brittany, the Irish painter Helen Mabel Trevor became interested in capturing with honesty the lives of the fishing people, their customs and traditions, particularly those of the women, whose husbands and sons were in constant danger while at sea. This aged Breton mother rests on her cane, her hands entwined with rosary beads. Those hands represent a life of hard work endured with a steadfast religious faith. Through piercing eyes, her unflinching gaze reflects the strength of character required of her throughout her life as a fisherman's wife and mother.

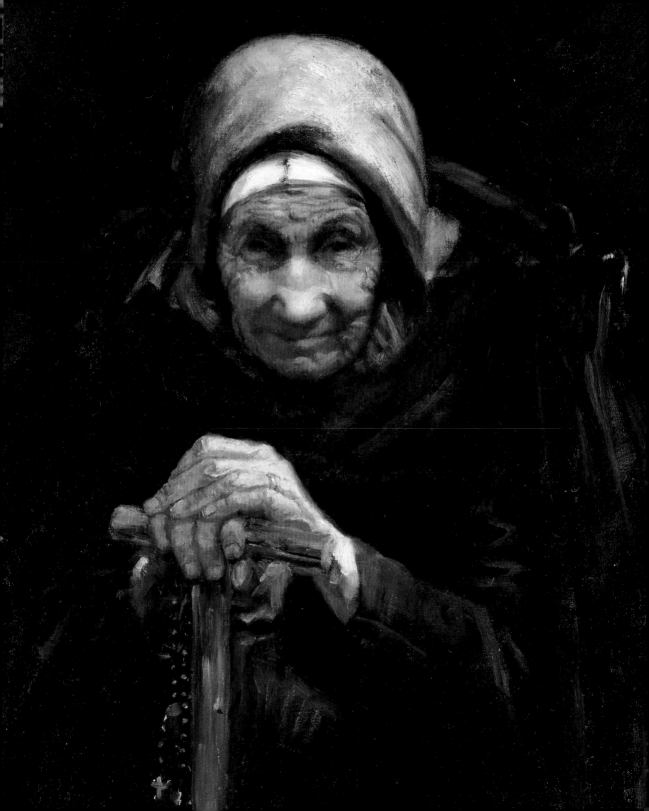

26 Monday · Luan

27 Tuesday · Máirt

28 Wednesday · Céadaoin

29 Thursday · Déardaoin

30 Friday · Aoine

31 Saturday · Satharn
New Year's Eve

1 Sunday · Domhnach
New Year's Day

2023 January · Eanáir

Louise Catherine Breslau, *Portrait of Bergliot Björnson, later Madame Ibsen,* **1889**

Swiss-born Breslau studied in Paris at the Académie Julian, where she met Sarah Purser. They became flatmates and lifelong friends. Breslau won a gold medal at the Exposition Universelle in 1889, the first foreign woman artist to be so honoured. A second gold medal in 1900 led to her being awarded the *Légion d'honneur.* This portrait shows Bergliot Björnson, daughter of poet, novelist and dramatist Bjornsterne Björnson. Bergliot married Sigurd, son of playwright Henrik Ibsen. Her gown, decorated with lace fichu and gold belt, appears unboned. The Dress Reform Movement advocated loose gowns, which found popularity among artistic families like the Björnsons and Ibsens.

M	T	W	T	F	S	S
26	27	28	29	30	31	1
2	3	4	5	6	7	8
9	10	11	12	13	14	15
16	17	18	19	20	21	22
23	24	25	26	27	28	29
30	31	1	2	3	4	5

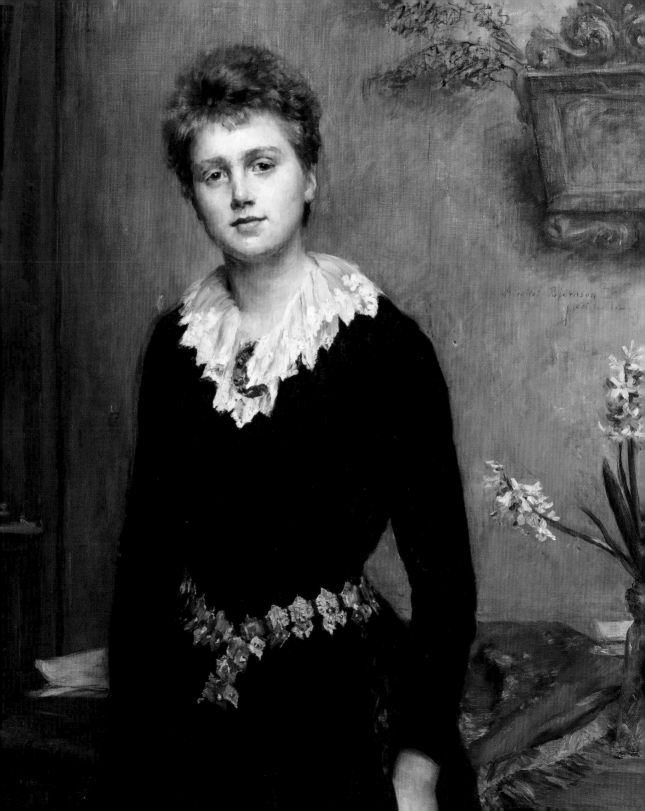

January · Eanáir
Week 1 · Seachtain 1

2 Monday · Luan
Bank Holiday (RoI and NI)

3 Tuesday · Máirt

4 Wednesday · Céadaoin

5 Thursday · Déardaoin

6 Friday · Aoine

7 Saturday · Satharn

8 Sunday · Domhnach

Sarah Purser, *A Lady Holding a Doll's Rattle,* **1885**
This lively sketch depicts an Irish woman, Mary Maud de la Poer Beresford. Purser spent the late summer of 1885 in Surrey with Mary Maud and her husband, Julian Sturgis, making seven paintings of them. Purser dedicated this painting as a gift to Sturgis with an inscription at the bottom of the canvas. As Mary Maud raises a punch-like rattle with one hand, her pose is captured with confident, rapid brushwork, evidence of Purser's time in Paris and the influence of French Impressionism.

M	T	W	T	F	S	S
26	27	28	29	30	31	1
2	3	4	5	6	7	8
9	10	11	12	13	14	15
16	17	18	19	20	21	22
23	24	25	26	27	28	29
30	31	1	2	3	4	5

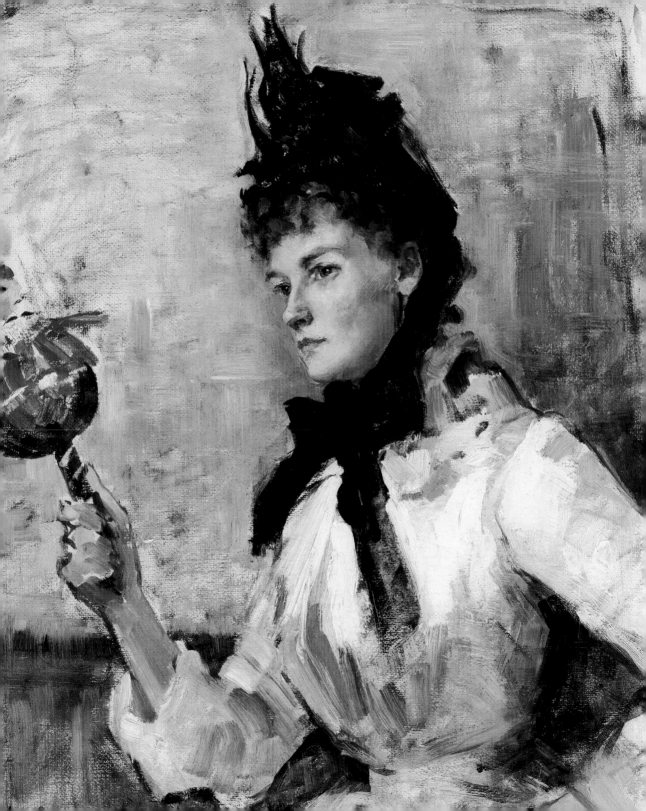

January · Eanáir
Week 2 · Seachtain 2

9 Monday · Luan

10 Tuesday · Máirt

11 Wednesday · Céadaoin

12 Thursday · Déardaoin

13 Friday · Aoine

14 Saturday · Satharn

15 Sunday · Domhnach

Harriet Osborne, *Interior,* **20th century**
This unpeopled interior was probably painted in Dublin before the artist's marriage, as it is signed 'H.O.' (her later works were signed Harriet Osborne O'Hagan). Although the overall tone of this room is dark, sunlight streams through a lace-curtained window to illuminate the ceramics and flowers on the table. Hanging on the walls are plates and framed pictures, while the dresser, chairs and table with twisted legs are typically Victorian.

M	T	W	T	F	S	S
26	27	28	29	30	31	1
2	3	4	5	6	7	8
9	10	11	12	13	14	15
16	17	18	19	20	21	22
23	24	25	26	27	28	29
30	31	1	2	3	4	5

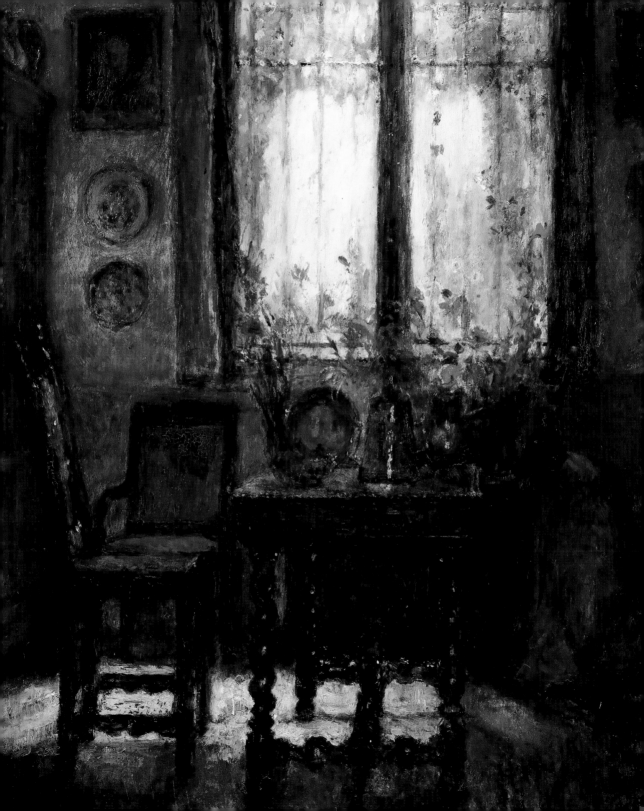

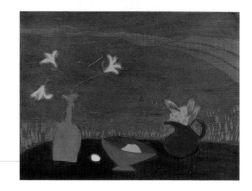

16 Monday · Luan

17 Tuesday · Máirt

18 Wednesday · Céadaoin

19 Thursday · Déardaoin

20 Friday · Aoine

21 Saturday · Satharn

22 Sunday · Domhnach

Jane O'Malley, *Still Life, La Geria,* **2013**

Born in Montreal, Jane Harris joined the artists' colony at St Ives, Cornwall, where she met Irish artist Tony O'Malley. They married in 1973, settled in Ireland in 1990, and travelled regularly to the Isles of Scilly, the Bahamas and the Canary Islands. Her subject matter ranged from still life, interiors, landscapes, gardens and animals to people. This carborundum print, inspired by time in Lanzarote, was made for Graphic Studio Dublin's Sponsors' Portfolio. The Studio originally published Sponsors' Portfolios from the 1960s to the 1980s to raise funds. In 2010 it re-launched the Portfolios as part of their 50th anniversary celebrations.

M	T	W	T	F	S	S
26	27	28	29	30	31	1
2	3	4	5	6	7	8
9	10	11	12	13	14	15
16	17	18	19	20	21	22
23	24	25	26	27	28	29
30	31	1	2	3	4	5

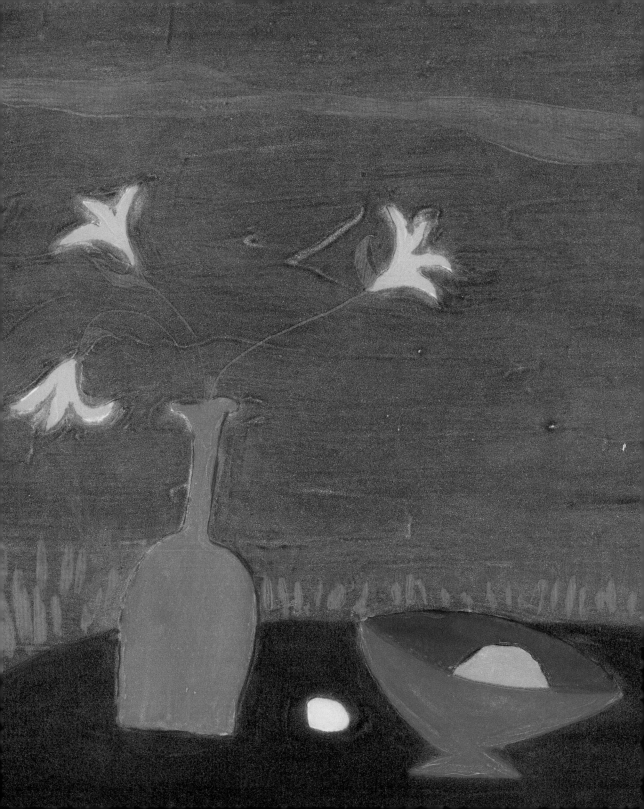

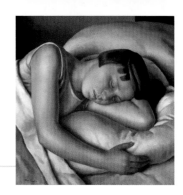

23 Monday · Luan

24 Tuesday · Máirt

25 Wednesday · Céadaoin

26 Thursday · Déardaoin

27 Friday · Aoine

28 Saturday · Satharn

29 Sunday · Domhnach

Dod Procter, *Sleeping Girl,* **c.1927**

Dod Procter (née Doris Shaw) joined the artistic community at Newlyn, Cornwall, where she trained at the art school run by Stanhope and Elizabeth Forbes. She met her future husband, the artist Ernest Procter, in Newlyn and worked there for the rest of her life. During the 1920s, Dod became highly regarded for her series of monumental paintings of introspective or sleeping young women, modelled, in this case, by Cissie Barnes, a local fisherman's daughter. Procter's restrained palette of silvery-grey tones, her cool detached style and strong modelling in light and shade serve to enhance the girl's sculptural appearance.

M	T	W	T	F	S	S
26	27	28	29	30	31	1
2	3	4	5	6	7	8
9	10	11	12	13	14	15
16	17	18	19	20	21	22
23	24	25	26	27	28	29
30	31	1	2	3	4	5

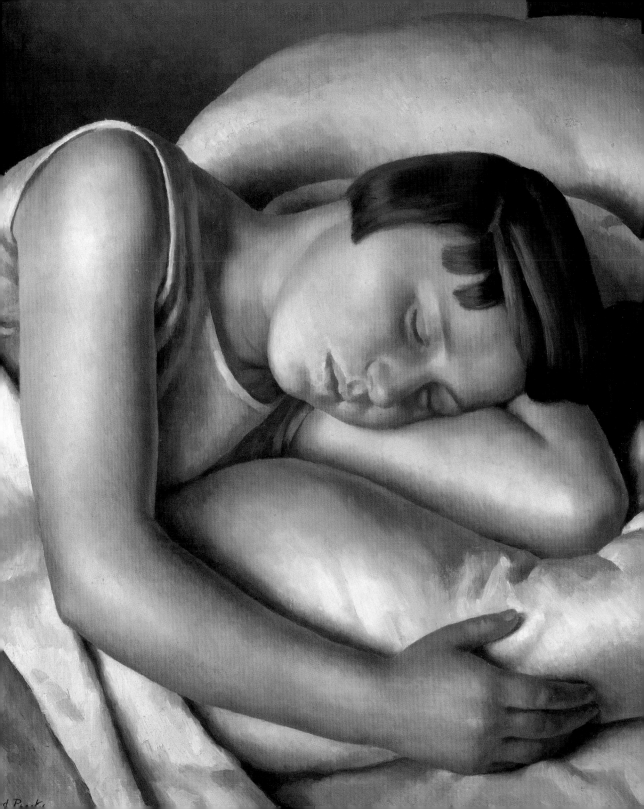

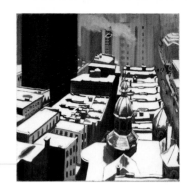

January · Eanáir
Week 5 · Seachtain 5

30 Monday · Luan

31 Tuesday · Máirt

1 Wednesday · Céadaoin
St Brigid's Day

February · Feabhra

2 Thursday · Déardaoin

3 Friday · Aoine

4 Saturday · Satharn

5 Sunday · Domhnach

Alice Neel, *Cityscape,* **1934**

American artist Alice Neel was living in New York when in December 1934 her partner Kenneth Doolittle destroyed most of her work in a jealous rage. She moved out of their Greenwich Village apartment and spent the following week in a hotel on 42nd Street, painting this snowy cityscape from her window. Looking northwards, the roof of Holy Cross Church is visible in the foreground, while in the right background, small touches of red indicate lights on theatre facades and short black strokes represent people coming and going. This painting marked a new beginning for Neel and for her art.

M	T	W	T	F	S	S
26	27	28	29	30	31	1
2	3	4	5	6	7	8
9	10	11	12	13	14	15
16	17	18	19	20	21	22
23	24	25	26	27	28	29
30	31	1	2	3	4	5

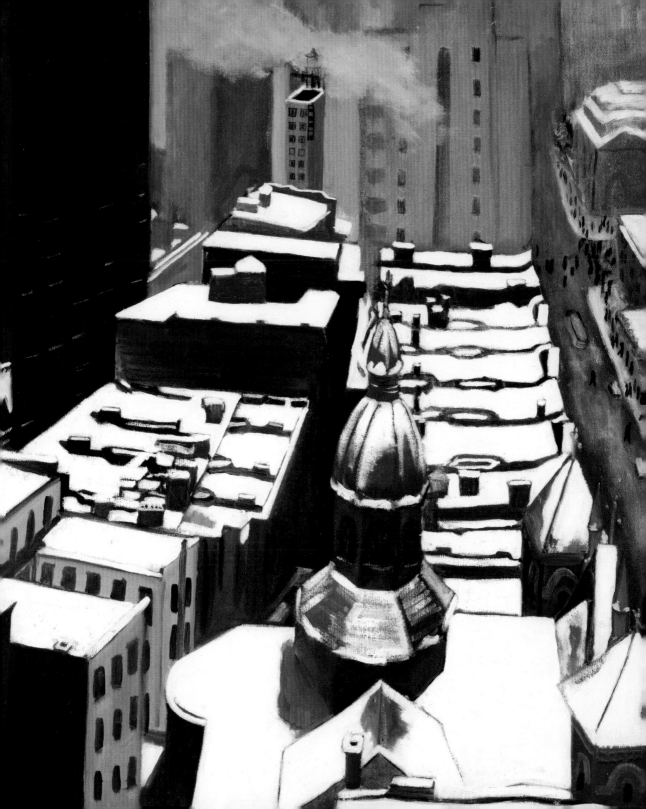

6 Monday · Luan

Bank Holiday (RoI)

7 Tuesday · Máirt

8 Wednesday · Céadaoin

9 Thursday · Déardaoin

10 Friday · Aoine

11 Saturday · Satharn

12 Sunday · Domhnach

Rosalba Carriera, *Spring,* **c.1740**

Born in Venice, Carriera initially designed patterns for *point de Venise* lace. When trade in that medium faded, she turned to painting lids of snuff boxes and miniature portraits. She found that her preference for soft effects was best suited to pastel. She was invited to Paris by the collector Pierre Crozat, arriving in 1720. She painted about 50 portraits of members of the court and aristocracy, mixing with their social circle. Her diaries reveal that she was on familiar terms with French artists, patrons and royalty. She began to depict allegorical representations of the four seasons in 1713, with most of her sets dating from the 1720s.

M	T	W	T	F	S	S
30	31	1	2	3	4	5
6	7	8	9	10	11	12
13	14	15	16	17	18	19
20	21	22	23	24	25	26
27	28	1	2	3	4	5

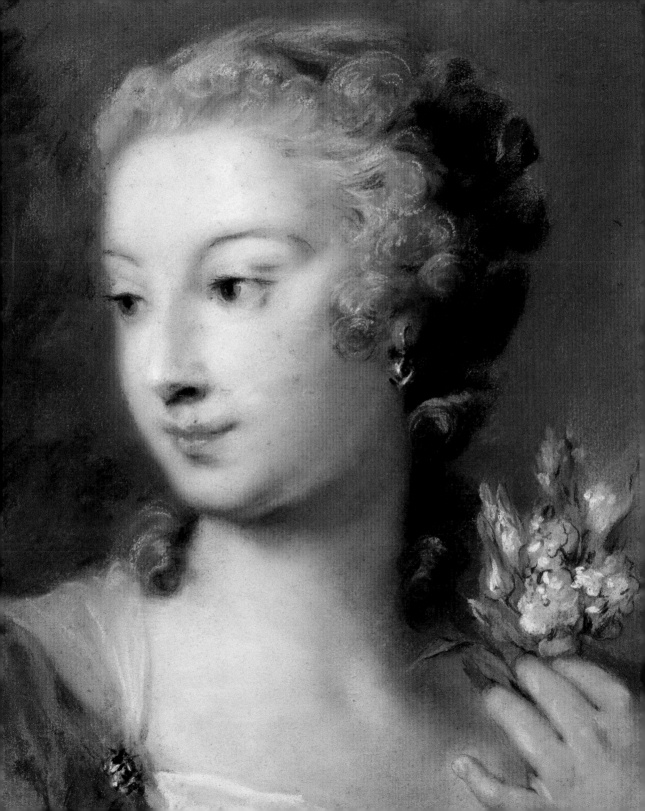

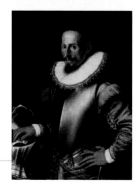

13 Monday · Luan

14 Tuesday · Máirt
St Valentine's Day

15 Wednesday · Céadaoin

16 Thursday · Déardaoin

17 Friday · Aoine

18 Saturday · Satharn

19 Sunday · Domhnach

Lavinia Fontana, *Portrait of a Gentleman in Armour,* **late 1590s**

Born in Bologna, Fontana became in high demand for her skilful portraits. She is recognised as one of the first European women artists to have achieved a successful public career. This sitter stands proudly with one hand on hip, the other on his helmet, gazing at the viewer, a smile touching the corners of his lips. Light reflects brilliantly against one side of his moulded breastplate, while illuminating his helmet in the lower left corner. Fontana pays meticulous attention to detail in rendering the textures of delicate lace collar and cuffs, shiny metal armour, sumptuous silk and human skin and hair.

M	T	W	T	F	S	S
30	31	1	2	3	4	5
6	7	8	9	10	11	12
13	14	15	16	17	18	19
20	21	22	23	24	25	26
27	28	1	2	3	4	5

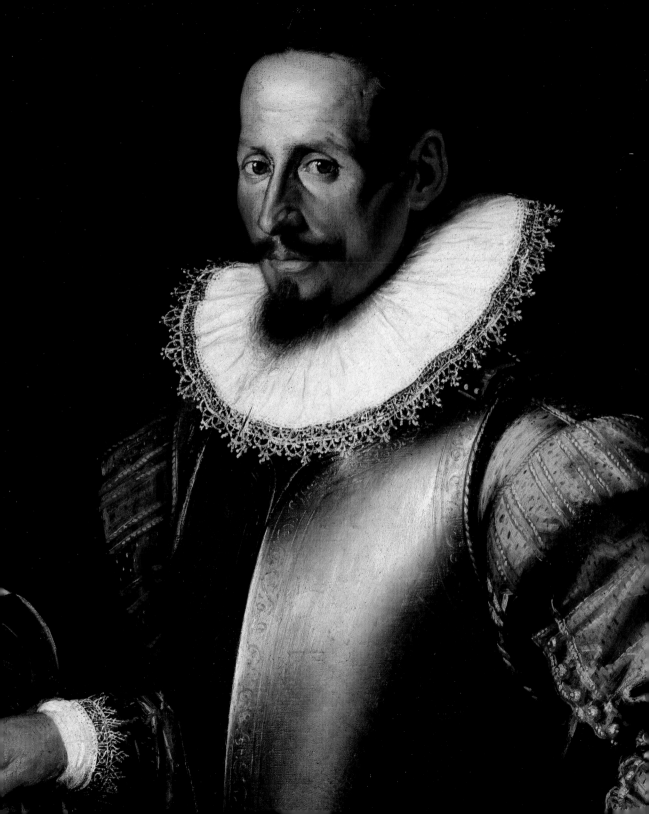

February · Feabhra
Week 8 · Seachtain 8

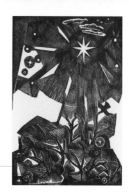

20 Monday · Luan

21 Tuesday · Máirt

22 Wednesday · Céadaoin

23 Thursday · Déardaoin

24 Friday · Aoine

25 Saturday · Satharn

26 Sunday · Domhnach

Elizabeth Rivers, *Star in the East,* **c.1960**

Rivers studied painting and wood engraving in London and Paris before moving to Dublin, where she assisted Evie Hone on stained glass designs, which strengthened the stylised, linear quality of her graphic work. Her engravings later combined human forms with natural elements such as clouds, light and stars. Religion played an increasingly important role in her work following her conversion to Catholicism in 1956. This semi-abstract engraving in blue ink typifies her work published by the Dolmen Press in the 1950s. A founder member of the Graphic Studio Workshop, where she taught engraving, Rivers contributed much to printmaking in Ireland.

M	T	W	T	F	S	S
30	31	1	2	3	4	5
6	7	8	9	10	11	12
13	14	15	16	17	18	19
20	21	22	23	24	25	26
27	28	1	2	3	4	5

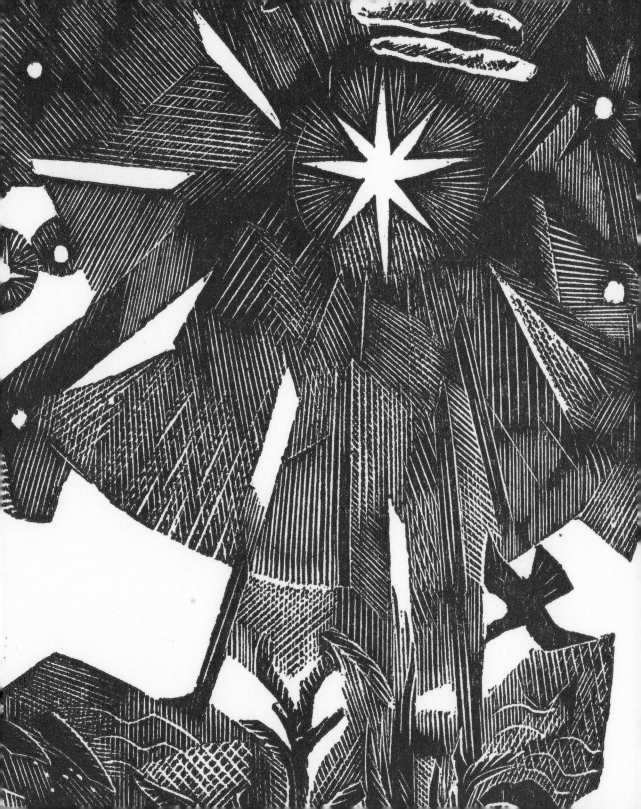

February • Feabhra
Week 9 • Seachtain 9

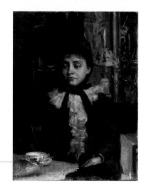

27 Monday • Luan

28 Tuesday • Máirt

1 Wednesday • Céadaoin March • Márta

2 Thursday • Déardaoin

3 Friday • Aoine

4 Saturday • Satharn

5 Sunday • Domhnach

Sarah Purser, *Le Petit Déjeuner,* **1881**

The model for this painting was Maria Feller, an Italian music and voice student who shared an apartment in Paris with Purser. On the table before the model, a croissant and cup and saucer remain untouched, as she allows herself to daydream. Feller's expression is moody and pensive, her ennui reminiscent of a number of works by Edgar Degas in which he evoked the lazy ambience of Parisian café life. Purser met Degas in Paris and was strongly influenced by him at this time in her career.

M	T	W	T	F	S	S
30	31	1	2	3	4	5
6	7	8	9	10	11	12
13	14	15	16	17	18	19
20	21	22	23	24	25	26
27	28	1	2	3	4	5

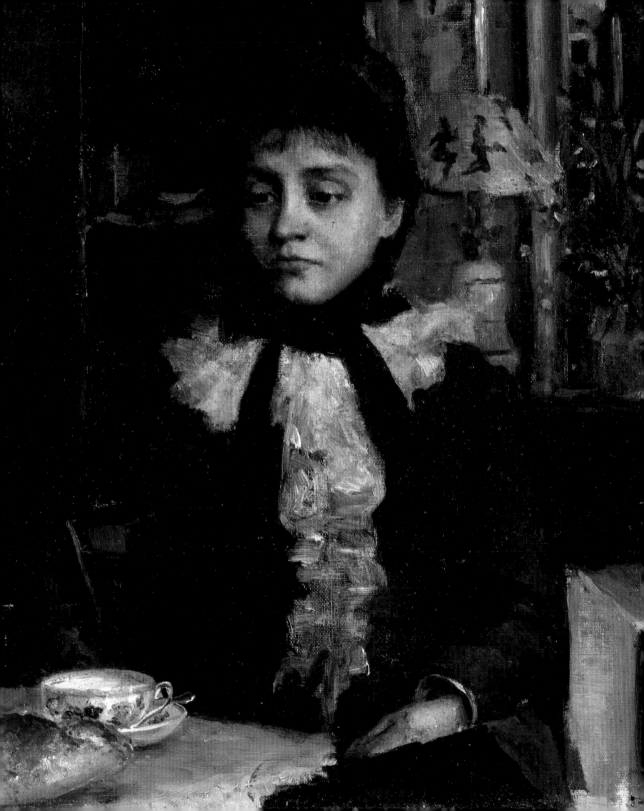

6 Monday · Luan

7 Tuesday · Máirt

8 Wednesday · Céadaoin
International Women's Day

9 Thursday · Déardaoin

10 Friday · Aoine

11 Saturday · Satharn

12 Sunday · Domhnach

Hilda van Stockum, *Evie Hone (1894–1955),* **1952**

Evie Hone posed for this portrait in her flat in the Dower House at Marley Grange, Rathfarnham. Through the window behind her you can see her studio, which was across the courtyard. Van Stockum's portrait makes one aware of Hone's quiet, private, reserved nature. The two artists were close friends and shared an interest in religion and spirituality. Hone's expression suggests the years of illness and pain which she endured as a result of infantile paralysis, while her hands reveal the arthritic condition from which she suffered in later life.

M	T	W	T	F	S	S
27	28	1	2	3	4	5
6	7	8	9	10	11	12
13	14	15	16	17	18	19
20	21	22	23	24	25	26
27	28	29	30	31	1	2

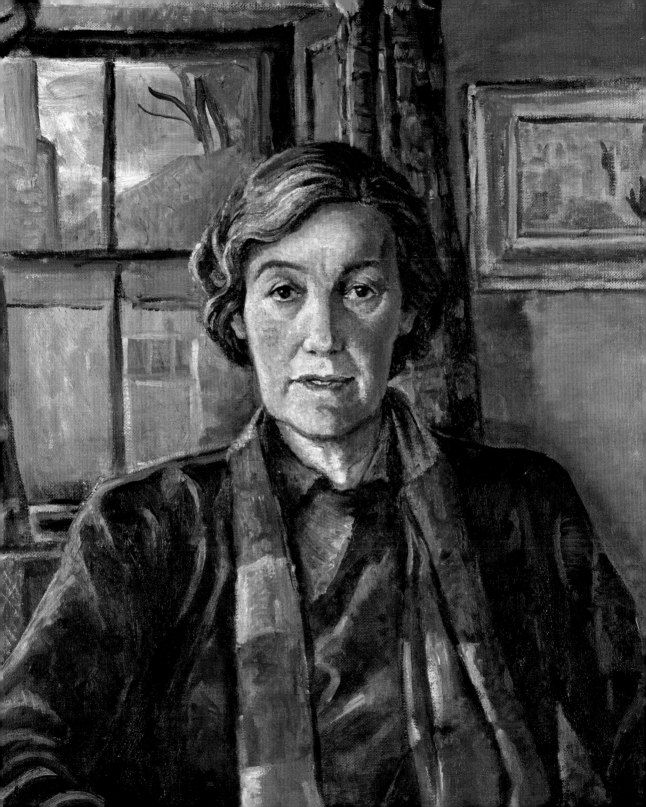

13 Monday · Luan

14 Tuesday · Máirt

15 Wednesday · Céadaoin

16 Thursday · Déardaoin

17 Friday · Aoine
St Patrick's Day (Bank Holiday RoI and NI)

18 Saturday · Satharn

19 Sunday · Domhnach
Mothering Sunday

Margaret Clarke, *St Patrick with a Group of Figures and an Irish Wolfhound,* **20th century**

Margaret Clarke (née Crilley) studied art in her native Newry at the Technical School there before winning a scholarship to the Metropolitan School of Art in Dublin, where she completed her training under William Orpen. She married Harry Clarke, the illustrator and stained glass artist, whose fame somewhat over-shadowed her own, but Margaret gained a respectable reputation as a portraitist, and became a regular exhibitor at the Royal Hibernian Academy. This allegorical study in watercolour, gouache, charcoal and graphite may have been inspired by time spent on the Aran Islands with her husband and the artist Seán Keating.

M	T	W	T	F	S	S
27	28	1	2	3	4	5
6	7	8	9	10	11	12
13	14	15	16	17	18	19
20	21	22	23	24	25	26
27	28	29	30	31	1	2

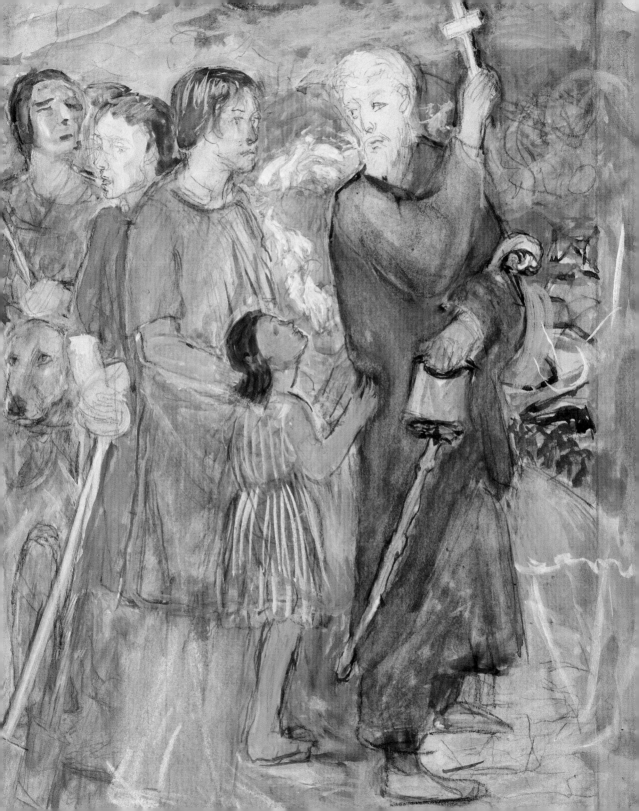

20 Monday • Luan

21 Tuesday • Máirt

22 Wednesday • Céadaoin

23 Thursday • Déardaoin

24 Friday • Aoine

25 Saturday • Satharn

26 Sunday • Domhnach

Mary Swanzy, *Self-Portrait with a Candle,* **c.1940**

A candle radiates a pulsating glow which illuminates Swanzy's delicate facial features and hands, but also emits a strange, fragmented light that lends the painting a visionary quality. One of several reflections on the Second World War by Swanzy, this picture takes on a more serious tone than is apparent at first glance. The candle may be symbolic of the austere conditions to which people had to adapt, of the fragile prospects for peace, or of the artist's own hopes and uncertainties for the future. This picture remained in her private collection until the 1970s, confirming its personal significance to her.

M	T	W	T	F	S	S
27	28	1	2	3	4	5
6	7	8	9	10	11	12
13	14	15	16	17	18	19
20	21	22	23	24	25	26
27	28	29	30	31	1	2

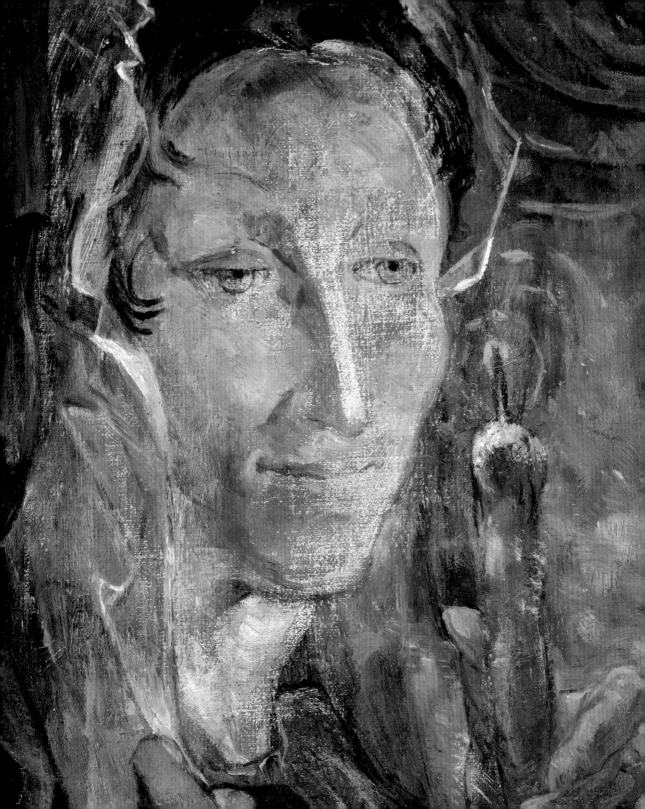

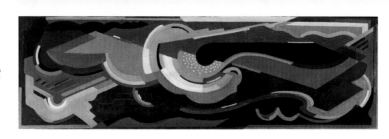

27 Monday · Luan

28 Tuesday · Máirt

29 Wednesday · Céadaoin

30 Thursday · Déardaoin

31 Friday · Aoine

1 Saturday · Satharn **April · Aibreán**

2 Sunday · Domhnach

Mainie Jellett, *A Composition – Sea Rhythm,* **1939**

Even when abstract, Jellett's patterns sought to replicate the harmony, balance and rhythm of nature. When she spoke of rhythm in her work, she was referring to the rhythm of nature but also of how she caused the viewer's eye to move rhythmically through her pictures. She spoke of the ability of colour to create harmony too. In the 1930s her work often embodied elemental forces: earth, wind, fire and water, the latter a reminder of her connection with the sea. Jellett enjoyed sea swimming throughout her life and here, the swirls of blue, green and white emulate the rhythmic pattern of water in motion.

M	T	W	T	F	S	S
27	28	1	2	3	4	5
6	7	8	9	10	11	12
13	14	15	16	17	18	19
20	21	22	23	24	25	26
27	28	29	30	31	1	2

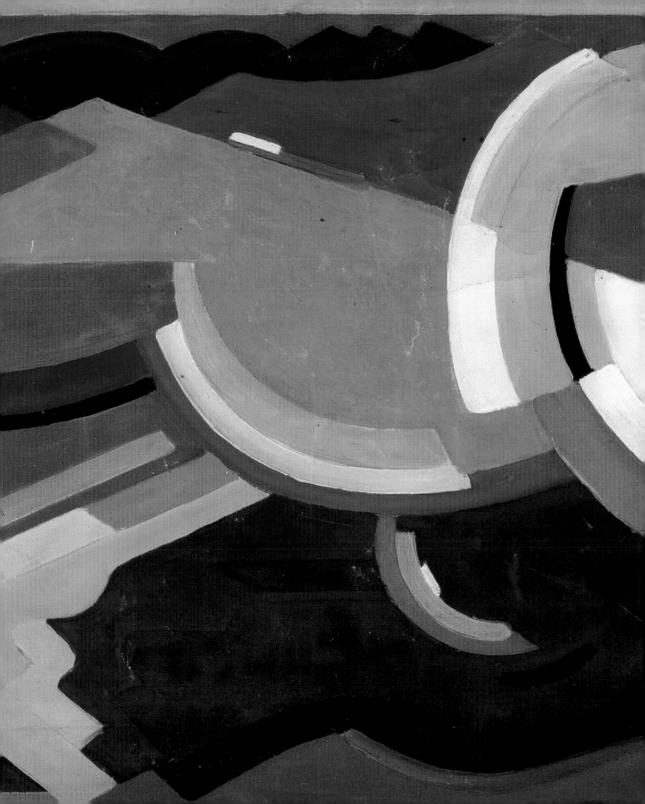

3 Monday · Luan

4 Tuesday · Máirt

5 Wednesday · Céadaoin

6 Thursday · Déardaoin

7 Friday · Aoine
Good Friday

8 Saturday · Satharn

9 Sunday · Domhnach
Easter Sunday

Angelica Kauffmann, *Portrait of Mrs Hellen (Dorothea Daniel),* **c. late 18th century**

Swiss artist Angelica Kauffman was initially active in Italy. Having attracted the patronage of British grand tourists, she moved to London, spending almost 20 years there, where she was a founding member of the Royal Academy. She gained international fame and patrons from Philadelphia to Warsaw. She visited Ireland in 1771 when she painted the portraits of Dorothea Daniel (d. 1806) and her husband George Robert Hellen (1725–1793), an Irish politician and judge. He was Solicitor-General for Ireland from 1777–79. In 1761 Hellen had married Dorothea Daniel, who was noted for her wealth, beauty and charm. They had four daughters.

M	T	W	T	F	S	S
27	28	29	30	31	1	2
3	4	5	6	7	8	9
10	11	12	13	14	15	16
17	18	19	20	21	22	23
24	25	26	27	28	29	30

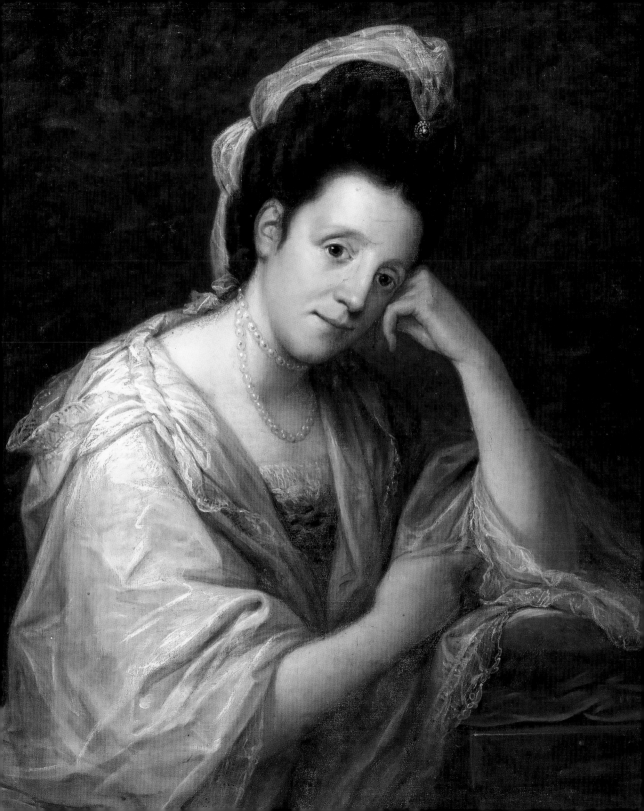

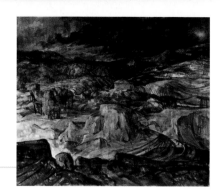

10 Monday · Luan
Easter Monday (Bank Holiday RoI and NI)

11 Tuesday · Máirt

12 Wednesday · Céadaoin

13 Thursday · Déardaoin

14 Friday · Aoine

15 Saturday · Satharn

16 Sunday · Domhnach

Mary Swanzy, *A Landscape,* **mid-20th century**

During her long and complex career, the Irish artist Mary Swanzy embraced at different times elements of Post-Impressionism, Cubism, Expressionism, Futurism and Surrealism. The Second World War greatly impacted on her art, which became tinged with foreboding. Paintings like *A Landscape* display subtly layered, blended colours and fragmented forms, yet possess an ominous note, apparent here in the black and red notes in the dark moody sky. Allegory and symbolism took on a new role in her highly personal art during and after the war, but as time progressed, her work softened and took on a more lyrical, visionary quality.

M	T	W	T	F	S	S
27	28	29	30	31	1	2
3	4	5	6	7	8	9
10	11	12	13	14	15	16
17	18	19	20	21	22	23
24	25	26	27	28	29	30

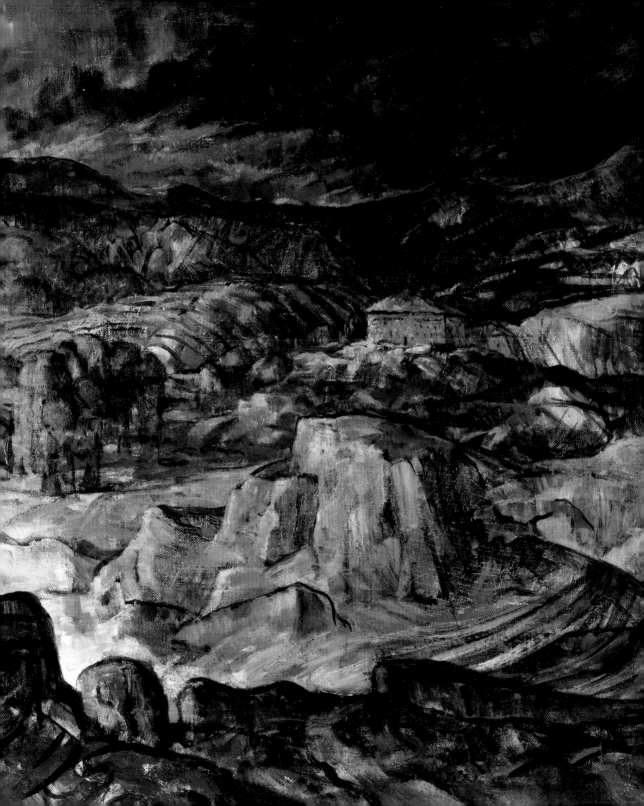

17 Monday · Luan

18 Tuesday · Máirt

19 Wednesday · Céadaoin

20 Thursday · Déardaoin

21 Friday · Aoine

22 Saturday · Satharn

23 Sunday · Domhnach

Margaret Clarke, *Ophelia,* **c.1926**

The tragic character of Ophelia from *Hamlet* was popular among 19th-century English and French artists, but unprecedented in Irish art. Clarke departs from conventional representations of Ophelia which showed her either in the water having drowned, or at the water's edge. Clarke prefers to locate her in a dark woodland setting, attired in plain, almost funereal dress. Looking disheveled and preoccupied, perhaps contemplating her fate, she is arguably more consistent with the Ophelia described by Shakespeare. Her figure is typical of Clarke's attenuated character studies and was modelled by Julia O'Brien, maid and nanny for the Clarke family at this time.

M	T	W	T	F	S	S
27	28	29	30	31	1	2
3	4	5	6	7	8	9
10	11	12	13	14	15	16
17	18	19	20	21	22	23
24	25	26	27	28	29	30

April · Aibreán
Week 17 · Seachtain 17

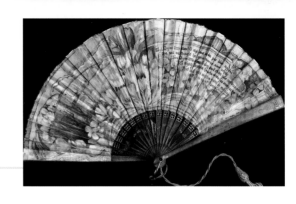

24 Monday · Luan

25 Tuesday · Máirt

26 Wednesday · Céadaoin

27 Thursday · Déardaoin

28 Friday · Aoine

29 Saturday · Satharn

30 Sunday · Domhnach

Elizabeth Yeats, *Hand-painted Fan,* **1905**
Elizabeth or 'Lolly' Yeats trained at Bedford Froebel College, London, taught watercolour painting and published four manuals on brush work before re-training as a typesetter at the Women's Printing Society, Westminster. She was a painter, art and Frobel teacher, printer and founder of the Dun Emer Press and Cuala Press. This silk fan, hand-painted in watercolour, features a landscape superimposed with crocuses and pansies which frame woodland on the left. Inscribed on the right is W. B. Yeats's poem 'Anashuya and Vijaya'. Trimmed with gold leaf, the fan has an engraved tortoiseshell handle and a gold cord and tassel.

M	T	W	T	F	S	S
27	28	29	30	31	1	2
3	4	5	6	7	8	9
10	11	12	13	14	15	16
17	18	19	20	21	22	23
24	25	26	27	28	29	30

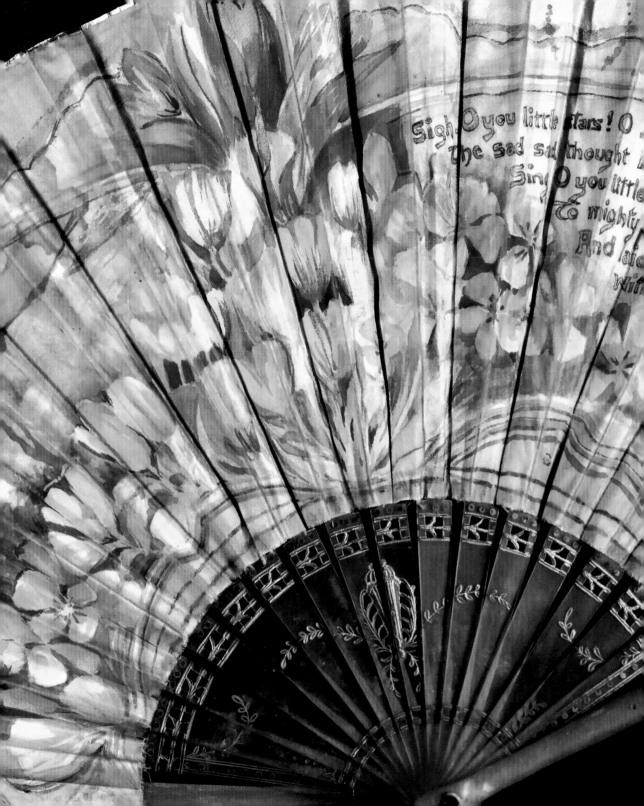

Sigh, O you little stars! O
the sad sad thought
Sing, O you little
to mighty
And lo
with

May · Bealtaine
Week 18 · Seachtain 18

1 Monday · Luan
Bank Holiday (RoI and NI)

2 Tuesday · Máirt

3 Wednesday · Céadaoin

4 Thursday · Déardaoin

5 Friday · Aoine

6 Saturday · Satharn

7 Sunday · Domhnach

Lavinia Fontana, *The Visit of the Queen of Sheba to King Solomon,* **c.1600**

In 1600, the Duke and Duchess of Mantua, Vincenzo I Gonzaga and Eleonora de' Medici stopped in Bologna, where Fontana painted them, en route to Florence to attend the marriage of Maria de' Medici to Henry IV of France. The Duke and Duchess appear in the guise of King Solomon and the Queen of Sheba. The Queen and her courtiers are attired in lace, brocaded silk, velvet, pearls and rubies. Their sumptuous costumes combine to convey the pomp and ceremony of Italian court life during the career of Fontana, one of the most successful female painters in the history of art.

M	T	W	T	F	S	S
1	2	3	4	5	6	7
8	9	10	11	12	13	14
15	16	17	18	19	20	21
22	23	24	25	26	27	28
29	30	31	1	2	3	4

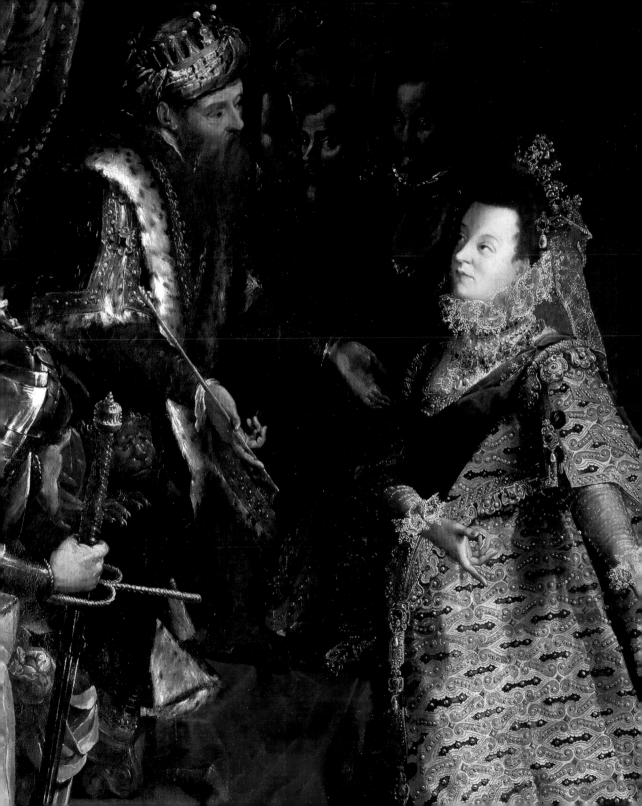

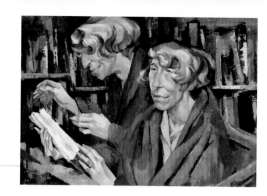

May · Bealtaine
Week 19 · Seachtain 19

8 Monday · Luan

9 Tuesday · Máirt

10 Wednesday · Céadaoin

11 Thursday · Déardaoin

12 Friday · Aoine

13 Saturday · Satharn

14 Sunday · Domhnach

Muriel Brandt, *Christine, Countess of Longford,* **c.1970s**

Christine Trew (1900-1980) read Classics at Somerville College, Oxford, where she met Edward Pakenham, later sixth Earl of Longford. They married and moved to Ireland in 1925, dividing their time between Dublin and Pakenham Hall, now Tullynally Castle, Castlepollard, County Westmeath. They became shareholders of the Gate Theatre Company, for which Christine wrote plays, managed productions, designed costumes and adapted novels, including Jane Austen's *Pride and Prejudice*. Brandt painted a group portrait of Gate Theatre founders Micheál Mac Liammóir, Hilton Edwards and Christine Longford in 1971 to mark its reopening, and has skilfully captured the Countess in two related poses in this portrait.

M	T	W	T	F	S	S
1	2	3	4	5	6	7
8	9	10	11	12	13	14
15	16	17	18	19	20	21
22	23	24	25	26	27	28
29	30	31	1	2	3	4

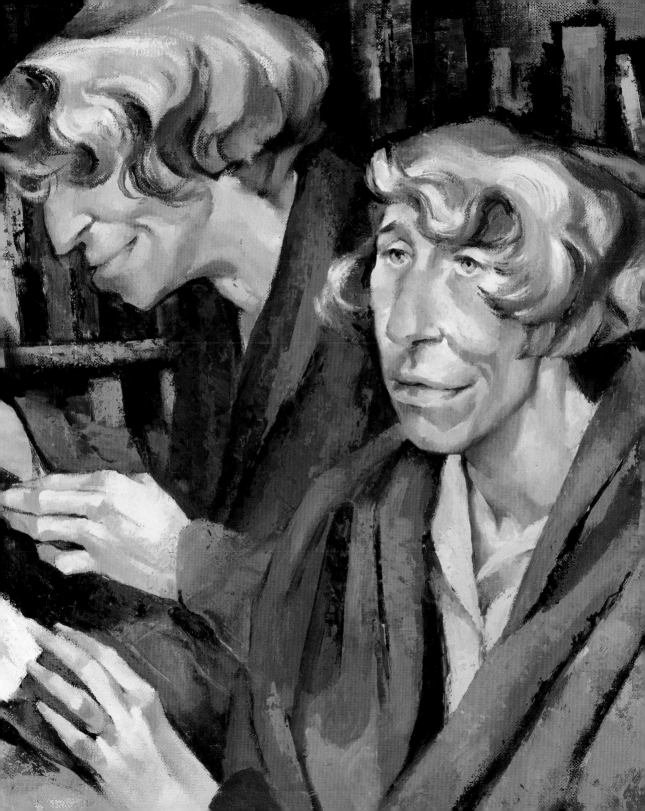

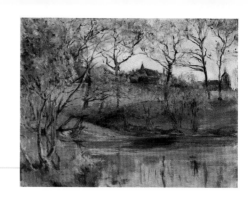

15 Monday • Luan

16 Tuesday • Máirt

17 Wednesday • Céadaoin

18 Thursday • Déardaoin

19 Friday • Aoine

20 Saturday • Satharn

21 Sunday • Domhnach

Sarah Paxton Ball Dodson, *Mayfield Convent,* **late 19th century**

Born in Philadelphia, Dodson studied at the Pennsylvania Academy of Fine Arts before travelling to Paris and becoming a leading American woman artist there in the late 19th century. In 1891 she left France and moved to Brighton, England, where her brother lived. Sarah turned increasingly to painting landscapes such as this, which depicts Mayfield Convent in East Sussex across a lake and through a screen of delicate trees. Mayfield, originally a medieval bishop's palace, was restored in the 19th century by E. W. Pugin and converted into a convent incorporating a girls' school, with a progressive educational philosophy for the time.

M	T	W	T	F	S	S
1	2	3	4	5	6	7
8	9	10	11	12	13	14
15	16	17	18	19	20	21
22	23	24	25	26	27	28
29	30	31	1	2	3	4

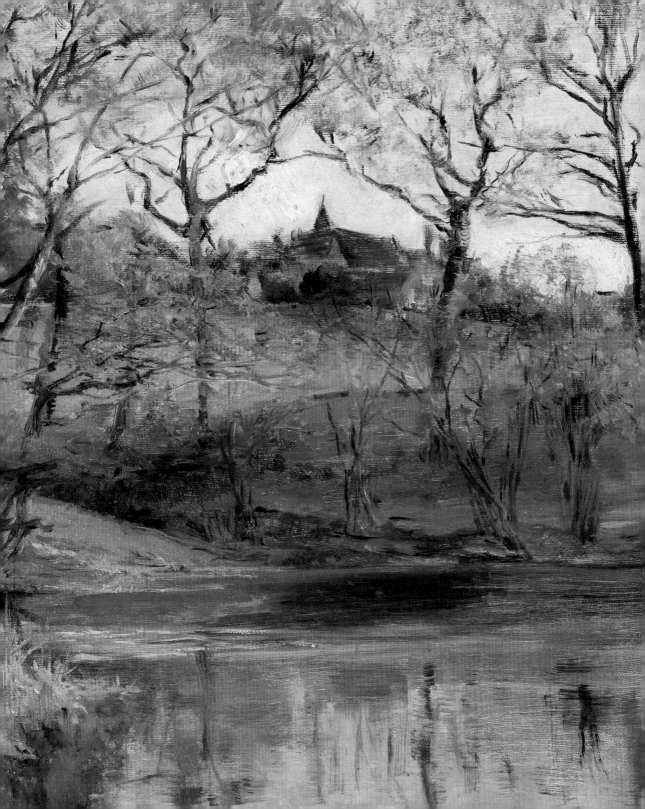

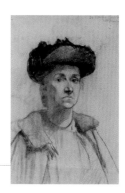

22 Monday · Luan

23 Tuesday · Máirt

24 Wednesday · Céadaoin

25 Thursday · Déardaoin

26 Friday · Aoine

27 Saturday · Satharn

28 Sunday · Domhnach

Sarah Purser, *Mrs Moore, 24 Powers Court,* **c. early 20th century**

In this charcoal study, Purser sensitively captures a Dublin woman's careworn features. She pays close attention to the sitter's face and hat, while rendering her coat loosely. She captures the woman's dignified expression, her down-turned mouth and jaw fixed in a set position, her eyes revealing more fragility. Purser inscribed the model's name and address in the top right corner, a practice she undertook for favoured sitters, perhaps in order to contact them again. Powers Court, an impoverished area between the Georgian houses of Upper and Lower Mount Streets, and close to Purser's home, Mespil House, was inhabited mostly by domestic servants.

M	T	W	T	F	S	S
1	2	3	4	5	6	7
8	9	10	11	12	13	14
15	16	17	18	19	20	21
22	23	24	25	26	27	28
29	30	31	1	2	3	4

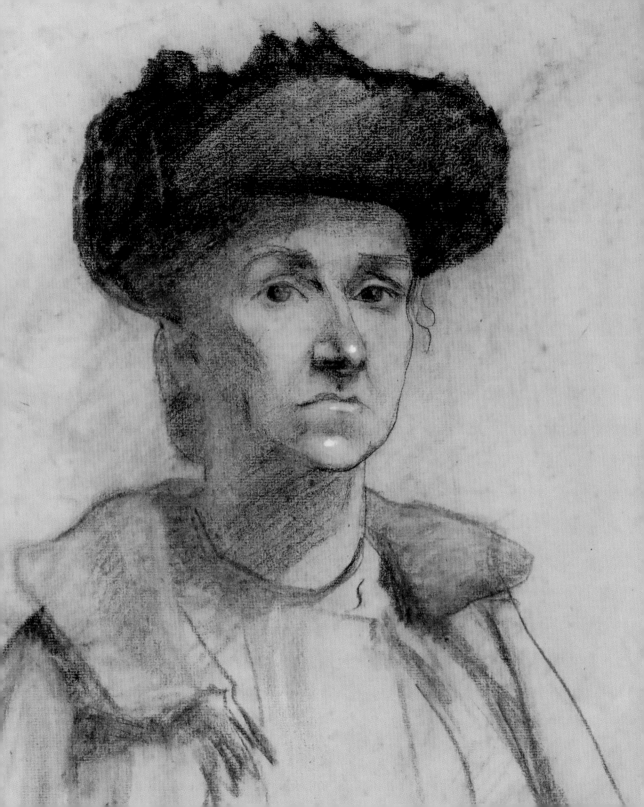

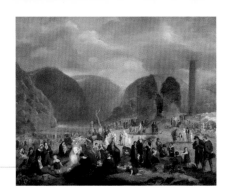

29 Monday · Luan

30 Tuesday · Máirt

31 Wednesday · Céadaoin

1 Thursday · Déardaoin June · Meitheamh

2 Friday · Aoine

3 Saturday · Satharn

4 Sunday · Domhnach

Maria Spilsbury Taylor, *Patron's Day at the Seven Churches, Glendalough,* **c.1816**

Spilsbury established herself as a portrait and genre painter in London before marrying John Taylor, a drawing master, and settling in Wicklow in 1813. They became members of the local Methodist congregation, and Maria painted religious and missionary subjects that reflected her own piety, including several set in Glendalough. At this ancient monastic site, pilgrims would gather annually on 3 June to celebrate the sixth-century St Kevin, founder and first abbot of Glendalough. Taylor concentrates here on recording the worship of the patron's day, against the backdrop of St Kevin's Cross, the Upper Lake, cathedral and round tower.

M	T	W	T	F	S	S
1	2	3	4	5	6	7
8	9	10	11	12	13	14
15	16	17	18	19	20	21
22	23	24	25	26	27	28
29	30	31	1	2	3	4

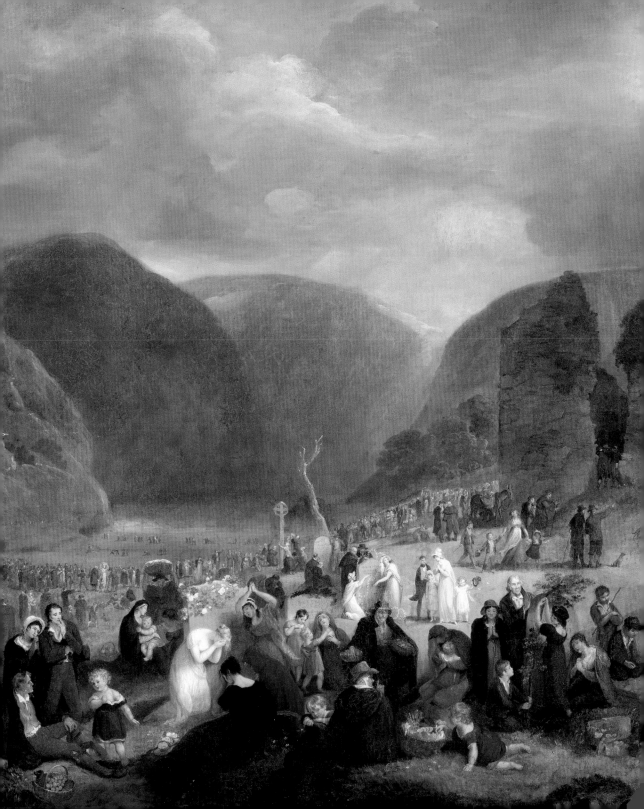

June · Meitheamh
Week 23 · Seachtain 23

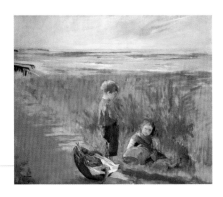

5 Monday · Luan
Bank Holiday (RoI)

6 Tuesday · Máirt

7 Wednesday · Céadaoin

8 Thursday · Déardaoin

9 Friday · Aoine

10 Saturday · Satharn

11 Sunday · Domhnach

Eva Gonzalès, *Brother and Sister at Grandcamp,* **1877–78**

Under the influence of Édouard Manet, Eva Gonzalès embraced painting *en plein air* (outdoors).
Grandcamp, a seaside resort in northern Brittany, was accessible by train from Paris and Gonzalès
holidayed and painted there in 1877–8. These children, having collected fish at market, have stopped on
their return to play at the edge of the grassy sand dunes. Colour is concentrated on their clothing, hair and
basket of fish. The light palette and broad brushstrokes reveal the artist's freedom of expression.

M	T	W	T	F	S	S
29	30	31	1	2	3	4
5	6	7	8	9	10	11
12	13	14	15	16	17	18
19	20	21	22	23	24	25
26	27	28	29	30	1	2

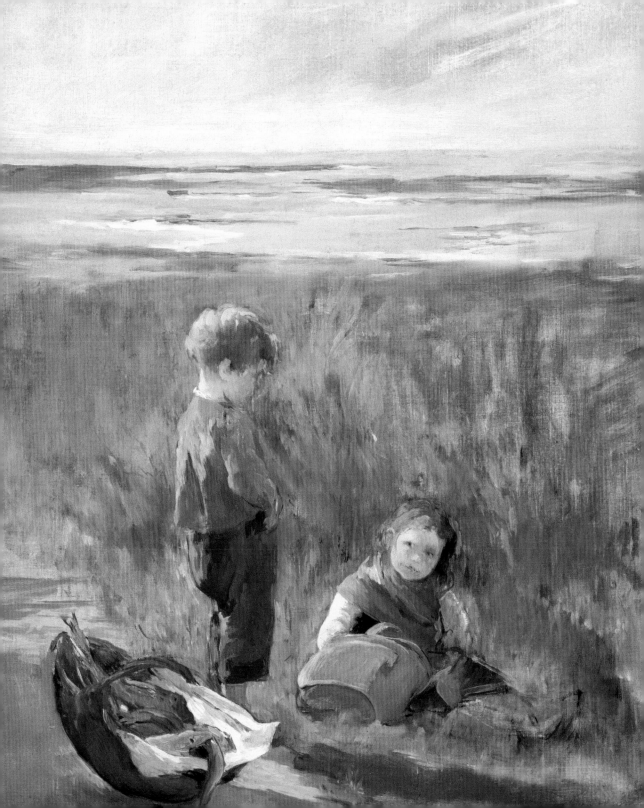

June • Meitheamh

Week 24 • Seachtain 24

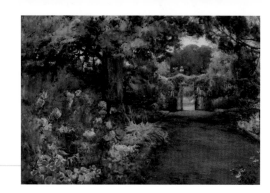

12 Monday • Luan

13 Tuesday • Máirt

14 Wednesday • Céadaoin

15 Thursday • Déardaoin

16 Friday • Aoine

17 Saturday • Satharn

18 Sunday • Domhnach

Mildred Anne Butler, *The Lilac Phlox, Kilmurry, Co. Kilkenny,* **c.1912**
Butler's home and garden at Kilmurry in Thomastown inspired much of her work. Her favourite path led from the house to a gate in the wall and was bordered by beds of lilac phlox, shown here flowering in late summer. To the right of the gate are yew hedges with seats cut in them, and the gate is framed by an overhanging tree. This accomplished watercolour evokes the nostalgia of long Edwardian summers.

M	T	W	T	F	S	S
29	30	31	1	2	3	4
5	6	7	8	9	10	11
12	13	14	15	16	17	18
19	20	21	22	23	24	25
26	27	28	29	30	1	2

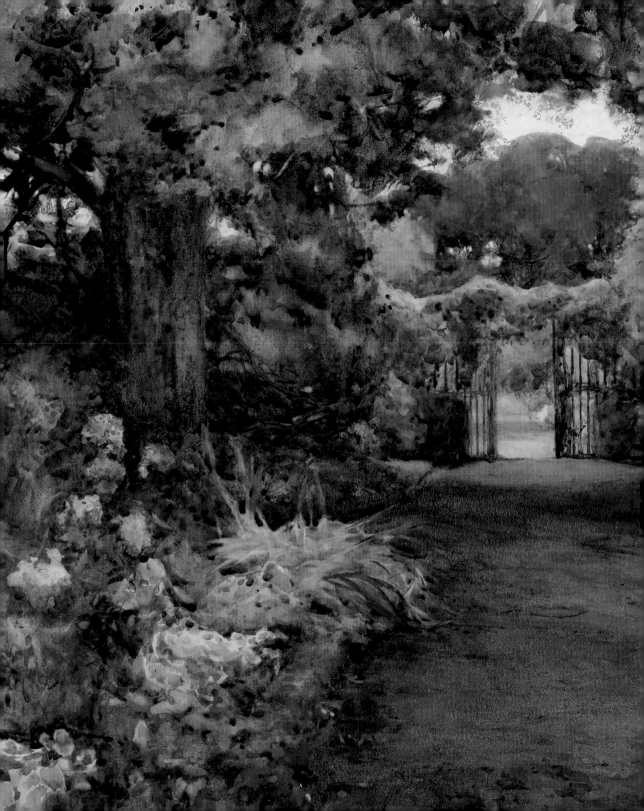

June • Meitheamh
Week 25 • Seachtain 25

19 Monday • Luan

20 Tuesday • Máirt

21 Wednesday • Céadaoin

22 Thursday • Déardaoin

23 Friday • Aoine

24 Saturday • Satharn

25 Sunday • Domhnach

Mary Swanzy, *Allegory,* **c.1945–49**

The Second World War profoundly affected Swanzy, who lived in London through the Blitz of 1940–41. She returned to Dublin unharmed, but her work was now tinged with foreboding and despair. She reflected on the impact of war on the psyche and its ravages on humanity. Allegory and symbolism took on a new role in her highly personal, expressionist art, in which she combined figures and colours with an ethereal, swirling light. Her post-war paintings adopted a visionary quality in which she layered complex symbolism, not limiting herself to one religion but blending Egyptian, Hindu and, here, Christian and Buddhist traditions.

M	T	W	T	F	S	S
29	30	31	1	2	3	4
5	6	7	8	9	10	11
12	13	14	15	16	17	18
19	20	21	22	23	24	25
26	27	28	29	30	1	2

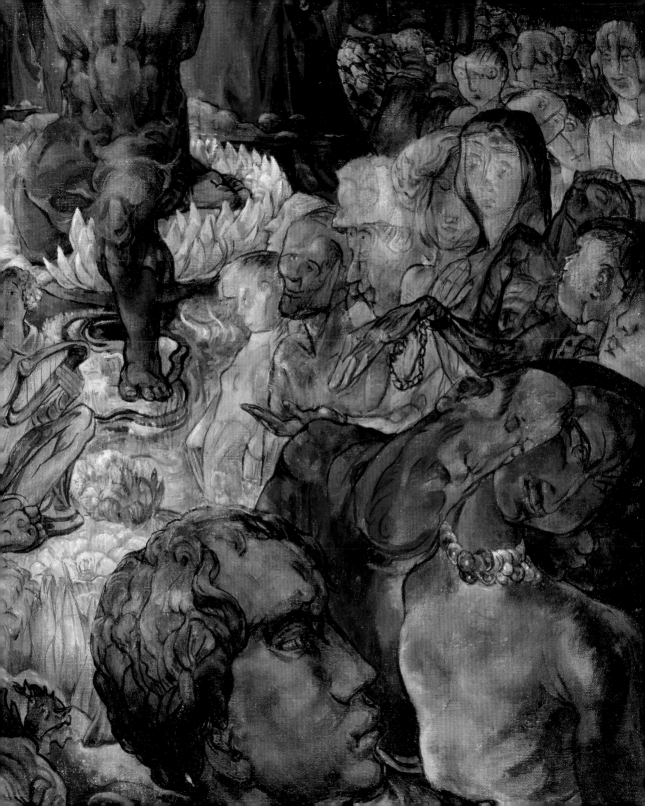

June · Meitheamh
Week 26 · Seachtain 26

26 Monday · Luan

27 Tuesday · Máirt

28 Wednesday · Céadaoin

29 Thursday · Déardaoin

30 Friday · Aoine

1 Saturday · Satharn

July · Iúil

2 Sunday · Domhnach

Rosalba Carriera, *Summer,* **c.1740**

Carriera influenced a generation of 18th-century artists in France and England in the art of pastel. Settling in Paris, she worked for the court and aristocratic patrons. She created several pastels representing the seasons, mostly during the 1720s. Her diaries reveal that she began one set in 1725, the year in which fellow Venetian Antonio Vivaldi's *The Four Seasons* violin concertos had their first advertised performance. Rosalba depicted the seasons as women adorned with traditional seasonal attributes. Flowers and ears of corn identify this figure as *Summer,* whose pale complexion, lightly rouged cheeks and dark eyes are enhanced by pearl earrings.

M	T	W	T	F	S	S
29	30	31	1	2	3	4
5	6	7	8	9	10	11
12	13	14	15	16	17	18
19	20	21	22	23	24	25
26	27	28	29	30	1	2

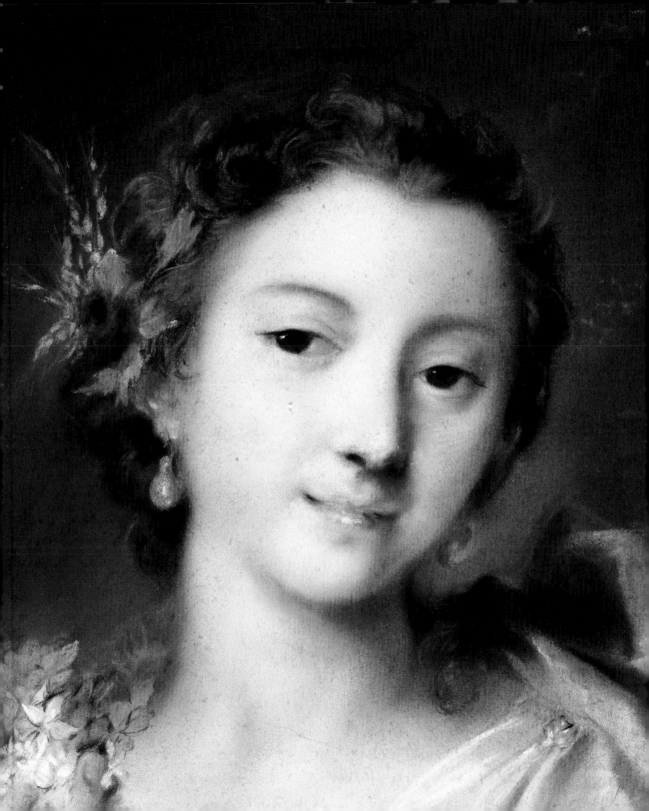

July · Iúil
Week 27 · Seachtain 27

3 Monday · Luan

4 Tuesday · Máirt

5 Wednesday · Céadaoin

6 Thursday · Déardaoin

7 Friday · Aoine

8 Saturday · Satharn

9 Sunday · Domhnach

Taffina Flood, *Winter Garden,* **c.1998**

This richly hued carborundum print was inspired by German Expressionist artist Emil Nolde's equally vivid painting *Women in the Garden* of 1915, in the National Gallery of Ireland's collection. Taffina Flood was commissioned to create her print as part of a series for the exhibition *Art Into Art: A Living Response To Past Masters*, held in 1998. The Gallery invited 30 artists to create prints inspired by works in the permanent collection. Those participating were members of Graphic Studio Dublin and invited artists. Flood is a graduate of the National College of Art and Design, Dublin where she now teaches.

M	T	W	T	F	S	S
26	27	28	29	30	1	2
3	4	5	6	7	8	9
10	11	12	13	14	15	16
17	18	19	20	21	22	23
24	25	26	27	28	29	30
31	1	2	3	4	5	6

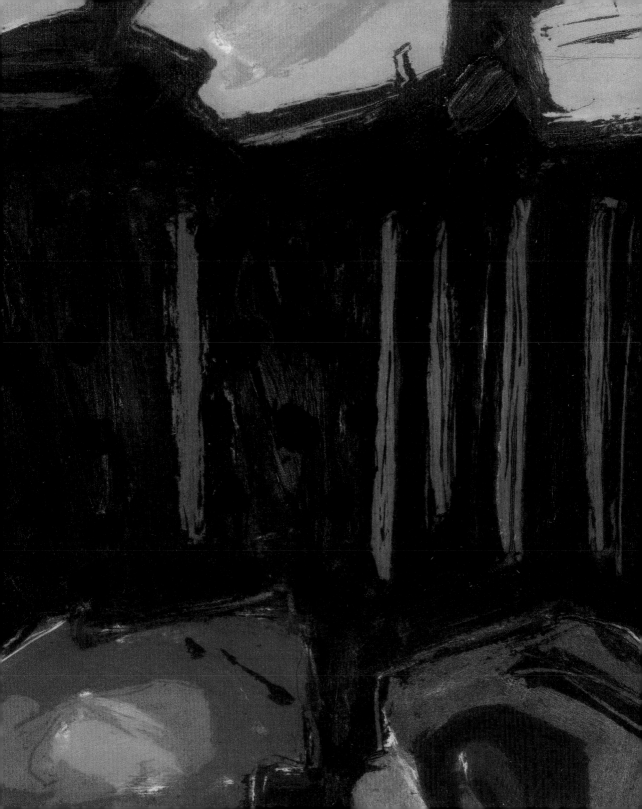

10 Monday · Luan

11 Tuesday · Máirt

12 Wednesday · Céadaoin

13 Thursday · Déardaoin

14 Friday · Aoine

15 Saturday · Satharn

16 Sunday · Domhnach

Letitia Hamilton, *Bantry Bay with a Sailing Boat, seen through Woodland,* **c.1940s**

Bantry Bay, complete with two sail boats, may be glimpsed through a screen of trees from high on a bank overlooking the bay, while a range of mountains is visible in the distance. The clear, vibrant colours and energetic brushstrokes are characteristic of the last 20 years of Hamilton's painting career. Having studied in Dublin under William Orpen, and in London and Belgium, Letitia Hamilton travelled extensively through France, Italy and Yugoslavia. She absorbed various French influences, as well as those of Vincent van Gogh, which are evident here in the *impasto,* or generous application of oil paint, and expressive technique.

M	T	W	T	F	S	S
26	27	28	29	30	1	2
3	4	5	6	7	8	9
10	11	12	13	14	15	16
17	18	19	20	21	22	23
24	25	26	27	28	29	30
31	1	2	3	4	5	6

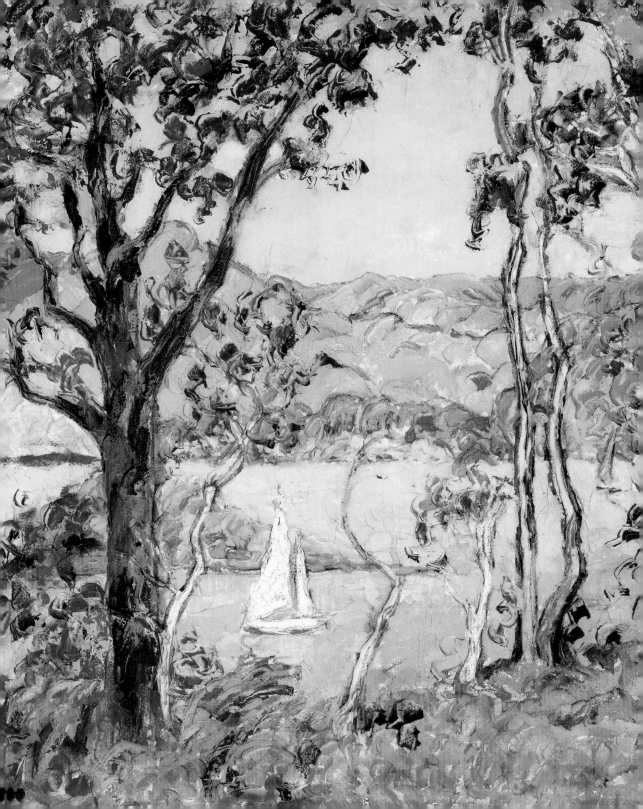

July • Iúil
Week 29 • Seachtain 29

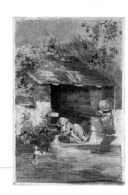

17 Monday • Luan

18 Tuesday • Máirt

19 Wednesday • Céadaoin

20 Thursday • Déardaoin

21 Friday • Aoine

22 Saturday • Satharn

23 Sunday • Domhnach

Frances 'Fanny' Wilmot Currey, *Woman Washing Clothes by a River,* **1879**

Currey was born in Lismore, County Waterford. A leading horticulturalist, she owned the Warren Nursery there and was Ireland's first world-famous daffodil breeder. She trained in art in London and Paris and travelled extensively on the Continent. A founding member of the Water Colour Society of Ireland from its inception as the Irish Amateur Drawing Society in Lismore in 1870, Currey served as its secretary and was a regular exhibitor until 1902. Her work was of a consistently professional standard, as is evident in this image of a woman in Breton garb pausing in her work to watch the passing ducks.

M	T	W	T	F	S	S
26	27	28	29	30	1	2
3	4	5	6	7	8	9
10	11	12	13	14	15	16
17	18	19	20	21	22	23
24	25	26	27	28	29	30
31	1	2	3	4	5	6

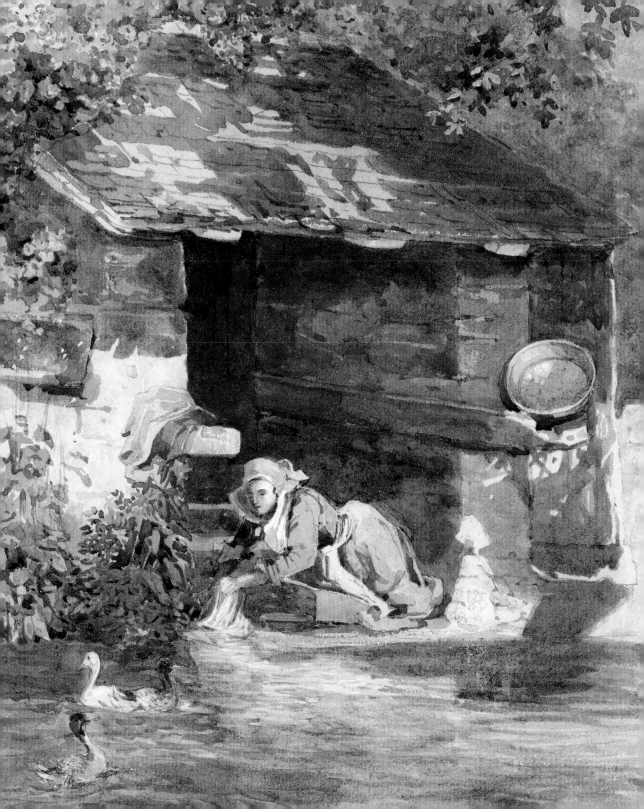

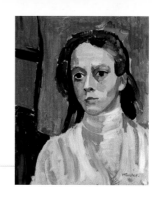

July · Iúil
Week 30 · Seachtain 30

24 Monday · Luan

25 Tuesday · Máirt

26 Wednesday · Céadaoin

27 Thursday · Déardaoin

28 Friday · Aoine

29 Saturday · Satharn

30 Sunday · Domhnach

Gabriele Münter, *Girl with a Red Ribbon,* **1908**

In 1908, the year she painted this picture, Münter settled in the village of Murnau, southern Bavaria, with her partner Wassily Kandinsky. Her work developed quickly at a time when she and Kandinsky were becoming leading members of the Expressionist movement. The girl depicted here wears a high-collared white blouse and a red ribbon in her hair. The green, red, purple and pink hues in her face reveal the influence of Van Gogh and Matisse. Other sources of inspiration are German folk art and Bavarian glass painting, the latter evident in the flat background colours separated by heavy, dark lines.

M	T	W	T	F	S	S
26	27	28	29	30	1	2
3	4	5	6	7	8	9
10	11	12	13	14	15	16
17	18	19	20	21	22	23
24	25	26	27	28	29	30
31	1	2	3	4	5	6

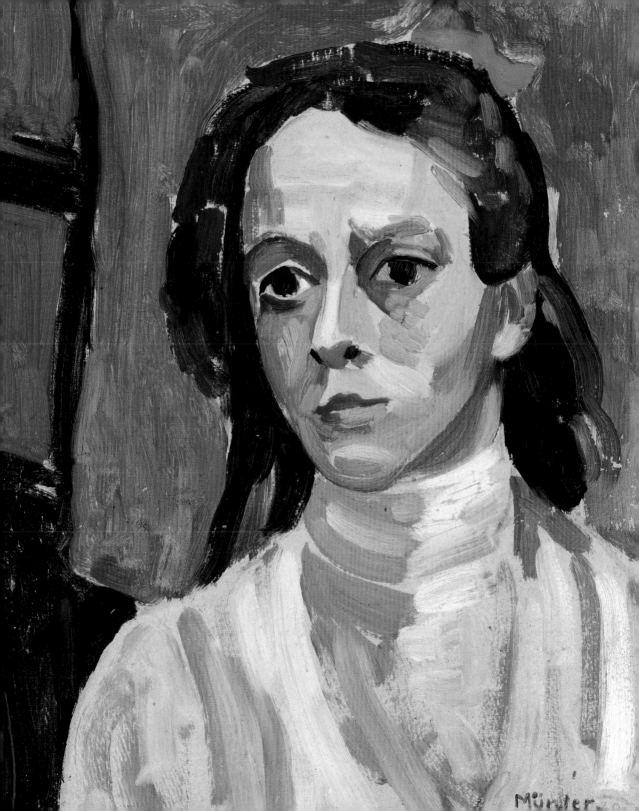

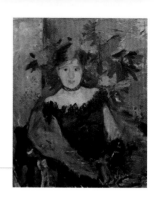

31 Monday · Luan

1 Tuesday · Máirt

August · Lúnasa

2 Wednesday · Céadaoin

3 Thursday · Déardaoin

4 Friday · Aoine

5 Saturday · Satharn

6 Sunday · Domhnach

Berthe Morisot, *Le Corsage Noir,* **1878**

Morisot trained with Camille Corot and was a friend of Édouard Manet, marrying his brother Eugène in 1874. In the same year she participated in the first Impressionist exhibition, the only female artist to do so. She portrayed the *intimiste* activities of bourgeois women, as in this painting. The black décolleté gown of the picture's title belonged to Morisot, who was photographed wearing it in c.1875. The model, Milly, is dressed for an evening at the theatre, accessorised with earrings, neck choker, gloves and olive green stole. Morisot adopts broad, dynamic brushstrokes for the ensemble while treating the face more delicately.

M	T	W	T	F	S	S
26	27	28	29	30	1	2
3	4	5	6	7	8	9
10	11	12	13	14	15	16
17	18	19	20	21	22	23
24	25	26	27	28	29	30
31	1	2	3	4	5	6

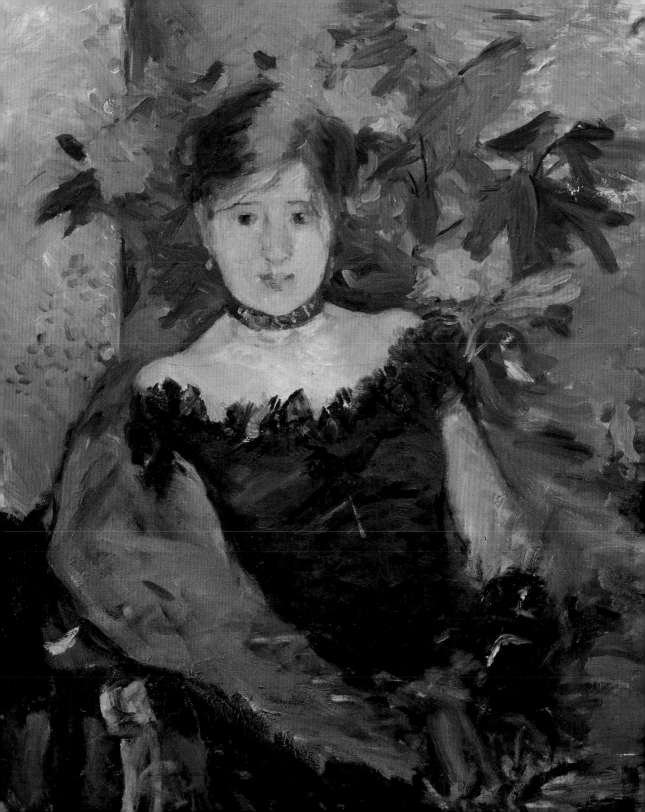

August • Lúnasa
Week 32 • Seachtain 32

7 Monday • Luan
Bank Holiday (RoI)

8 Tuesday • Máirt

9 Wednesday • Céadaoin

10 Thursday • Déardaoin

11 Friday • Aoine

12 Saturday • Satharn

13 Sunday • Domhnach

Mainie Jellett, *Nudes Dancing round a Fountain by Moonlight,* **c.1914**

Jellett began her artistic training with Elizabeth Yeats, who gave weekly lessons at the Jellett home in Fitzwilliam Square, and with Miss Manning. She then studied under Norman Garstin in Brittany, and at the Dublin Metropolitan School of Art, where William Orpen's influence was strong and where a considerable emphasis was placed on life drawing. This work dates from a time when she was preoccupied with figure painting, something she would continue to focus on at the Westminster School of Art. There she met fellow Irish artist Evie Hone, who became her lifelong friend, and with whom she would explore Cubism in Paris.

M	T	W	T	F	S	S
31	1	2	3	4	5	6
7	8	9	10	11	12	13
14	15	16	17	18	19	20
21	22	23	24	25	26	27
28	29	30	31	1	2	3

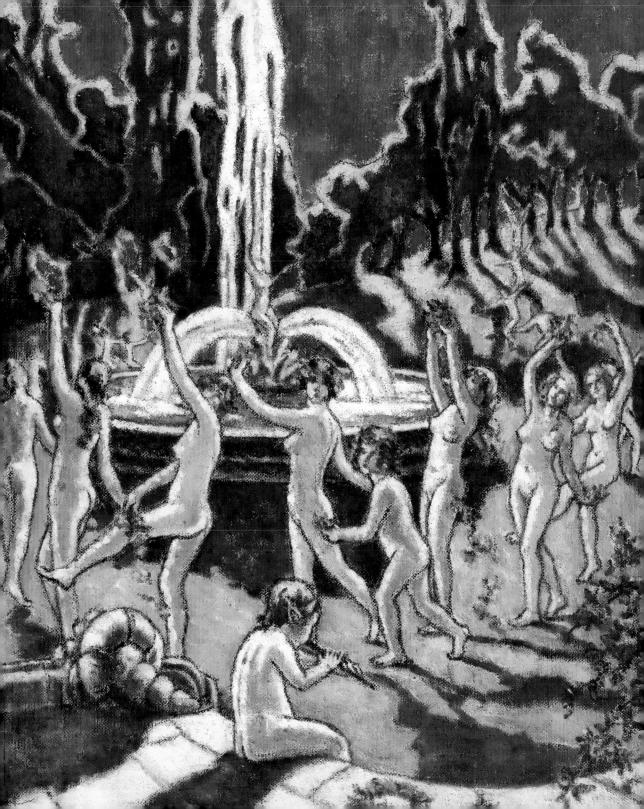

August · Lúnasa
Week 33 · Seachtain 33

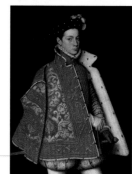

14 Monday · Luan

15 Tuesday · Máirt

16 Wednesday · Céadaoin

17 Thursday · Déardaoin

18 Friday · Aoine

19 Saturday · Satharn

20 Sunday · Domhnach

Sofonisba Anguissola, *Portrait of Prince Alessandro Farnese (1545–92), afterwards Duke of Parma and Piacenza,* **c.1560**

Prince Farnese, son of the Duke of Parma, was about 15 when this portrait was painted in Madrid by the distinguished Italian female artist Sofonisba Anguissola. His sumptuous costume includes a Moorish chamois leather cape embroidered with gold and silver wire, lined with ermine fur and trimmed with pearls. His doublet and gloves are leather, his velvet hat is trimmed with pearls and feathers, while his hose have embroidered satin bands. Anguissola was made lady-in-waiting to the Queen of Spain while Farnese later became Duke of Parma and Piacenza. He was the favourite nephew of King Philip II of Spain.

M	T	W	T	F	S	S
31	1	2	3	4	5	6
7	8	9	10	11	12	13
14	15	16	17	18	19	20
21	22	23	24	25	26	27
28	29	30	31	1	2	3

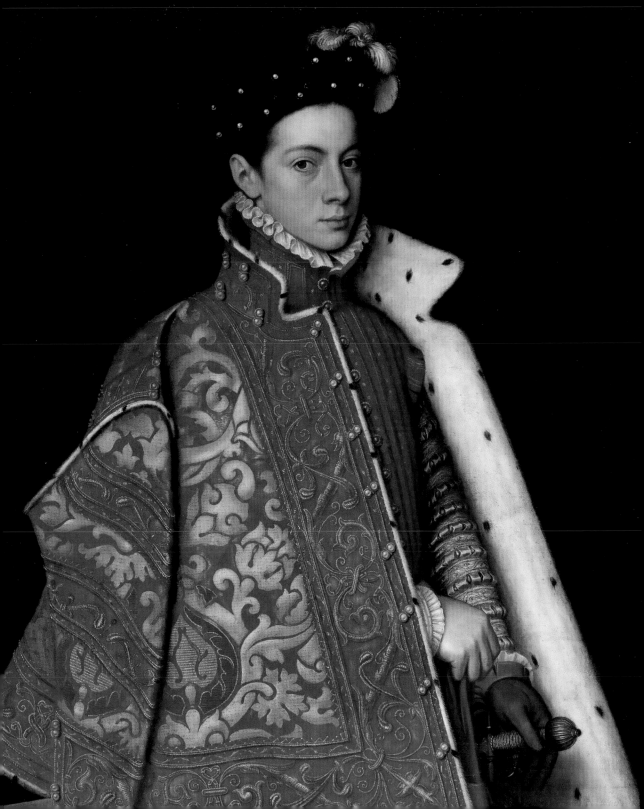

August · Lúnasa
Week 34 · Seachtain 34

21 Monday · Luan

22 Tuesday · Máirt

23 Wednesday · Céadaoin

24 Thursday · Déardaoin

25 Friday · Aoine

26 Saturday · Satharn

27 Sunday · Domhnach

Estella Solomons, *A View of Rosapenna from Breaghy Head,* **1931**

Solomons studied in Dublin, London and Paris, her work betraying the influence of Impressionism. Her landscapes express the vitality and energy of nature, achieved through her use of rich colour, applied liberally and confidently. Solomons became a frequent visitor to the artist George Russell's home in Donegal, using it as a base for exploring the wild headlands and the sea. Her approach to painting the Donegal coast is rapid and expressionist, employing wedges of gleaming colour with brilliant highlights to convey the churning sea, shifting light and clouds. Here she captures the essence of a sunny day on Breaghy Head.

M	T	W	T	F	S	S
31	1	2	3	4	5	6
7	8	9	10	11	12	13
14	15	16	17	18	19	20
21	22	23	24	25	26	27
28	29	30	31	1	2	3

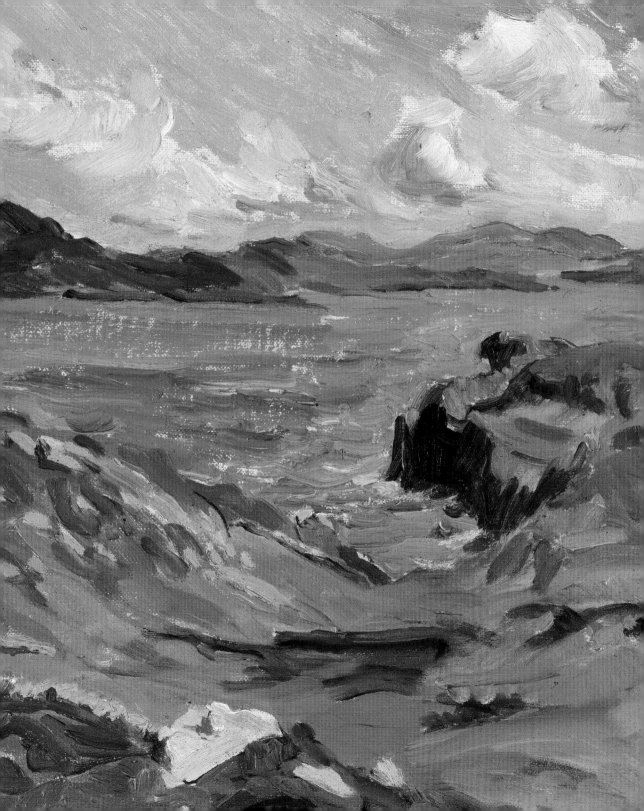

August · Lúnasa
Week 35 · Seachtain 35

28 Monday · Luan

29 Tuesday · Máirt

30 Wednesday · Céadaoin

31 Thursday · Déardaoin

1 Friday · Aoine September · Meán Fómhair

2 Saturday · Satharn

3 Sunday · Domhnach

Evie Hone, *A Landscape with a Tree,* **1943**

After training in London, Evie Hone studied Cubism in Paris, returning there over many summers. This view of a tree against fields and mountains is typical of the vitality of her later landscapes, in which her ability to capture a sense of place is evident. Hone has turned the background hills into rectangular screens to make a foil for the central grouping of fields and stones against which the central pattern of the tree is shown. This is characteristic of her expressionist work, showing the influence of Rouault, whom she admired. The treatment of the background, however, betrays earlier Cubist influences.

M	T	W	T	F	S	S
31	1	2	3	4	5	6
7	8	9	10	11	12	13
14	15	16	17	18	19	20
21	22	23	24	25	26	27
28	29	30	31	1	2	3

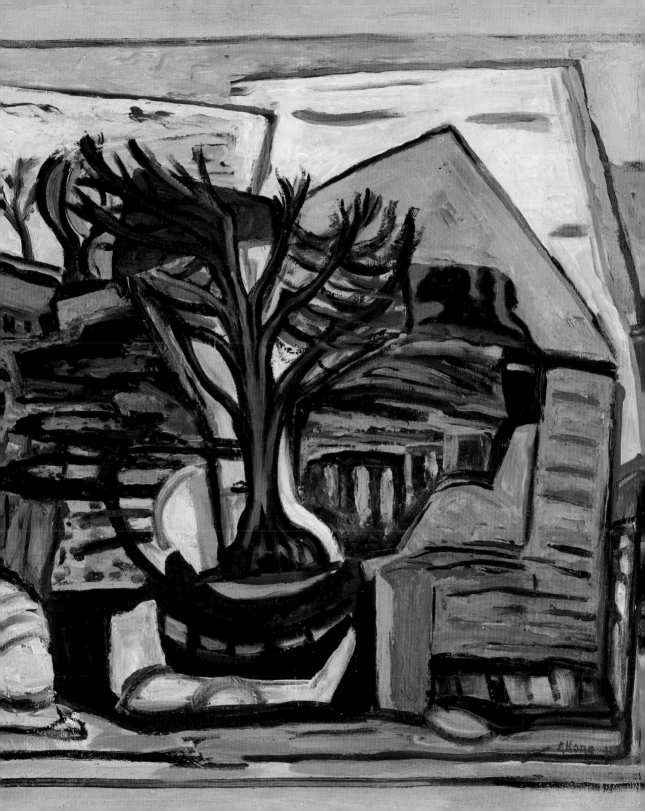

4 Monday · Luan

5 Tuesday · Máirt

6 Wednesday · Céadaoin

7 Thursday · Déardaoin

8 Friday · Aoine

9 Saturday · Satharn

10 Sunday · Domhnach

Mainie Jellett, *Achill Horses,* **1941**

Jellett visited Achill Island in 1936 and was struck by the colouring and atmosphere of its landscape, producing several works in which she interpreted its terrain and animals in her own Cubist style. She experimented with interlocking circles under the influence of Chinese art, and used serpentine shapes to portray the landscape, waves and horses, which appear to gallop through the sea. The curving forms of this energetic, rhythmic composition are complemented by the muted tones of brown, green, blue and grey that reflect the western light and landscape.

M	T	W	T	F	S	S
28	29	30	31	1	2	3
4	5	6	7	8	9	10
11	12	13	14	15	16	17
18	19	20	21	22	23	24
25	26	27	28	29	30	1

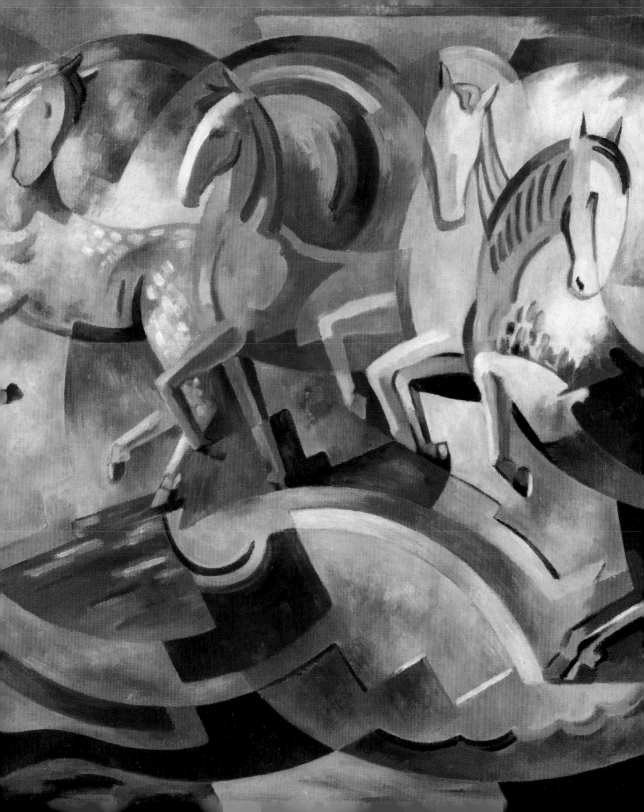

11 Monday · Luan

12 Tuesday · Máirt

13 Wednesday · Céadaoin

14 Thursday · Déardaoin

15 Friday · Aoine

16 Saturday · Satharn

17 Sunday · Domhnach

Julia Margaret Cameron, *After the Manner of Perugino (Mary Ryan),* **c.1865**

At the age of 48, Cameron received her first camera as a gift from her son. She created portraits and figure studies posed and costumed to illustrate biblical, mythological or literary narratives. She won acclaim for transforming photography into an art form. Her works are celebrated as among the most perceptive images of the Victorian era. At age 10, Mary Ryan (1848–1914) and her Irish mother were discovered begging on Putney Heath, London, by Cameron who, touched by her grace, took on Mary's upbringing. Ryan became her loyal maid and muse, and is styled here in the manner of Renaissance artist Perugino.

M	T	W	T	F	S	S
28	29	30	31	1	2	3
4	5	6	7	8	9	10
11	12	13	14	15	16	17
18	19	20	21	22	23	24
25	26	27	28	29	30	1

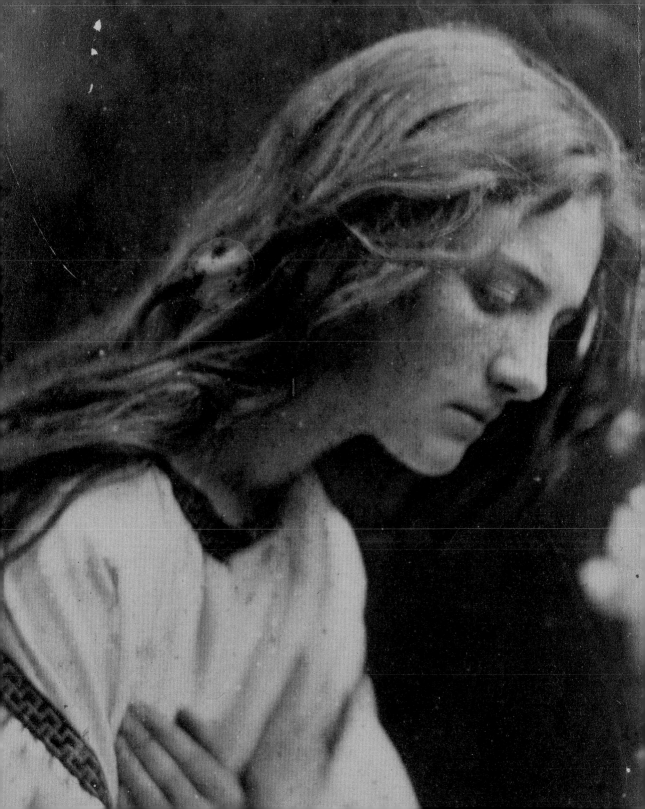

September · Meán Fómhair
Week 38 · Seachtain 38

18 Monday · Luan

19 Tuesday · Máirt

20 Wednesday · Céadaoin

21 Thursday · Déardaoin

22 Friday · Aoine

23 Saturday · Satharn

24 Sunday · Domhnach

Anne Yeats, *The Breaking Net,* **1966**

Anne, daughter of W. B. Yeats, studied at the Royal Hibernian Academy and Metropolitan School of Art. She became stage designer for the Abbey Theatre at age 16, and later its chief designer, preparing sets for her father's plays. During the 1940s she became a full-time artist, influenced by French modernism, evolving a distinctive, purposefully naive style. She worked in oil, ink, watercolour, wax and lithography. She moved to Dalkey in the 1960s, around which time she painted this work. A white bird with wings outstretched is silhouetted against the criss-crossed, broken lines of a net. Sea birds, symbolic of freedom, were among her favourite subjects.

M	T	W	T	F	S	S
28	29	30	31	1	2	3
4	5	6	7	8	9	10
11	12	13	14	15	16	17
18	19	20	21	22	23	24
25	26	27	28	29	30	1

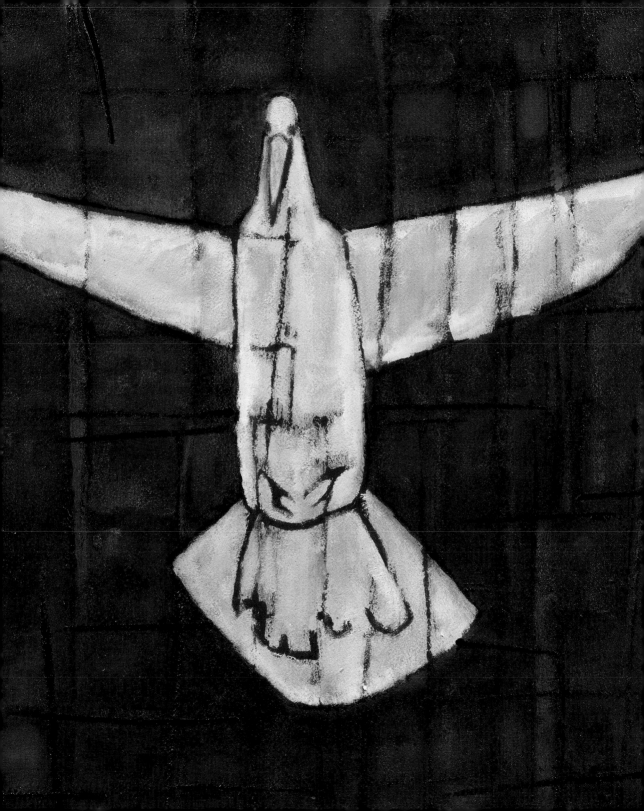

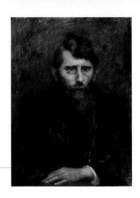

September · Meán Fómhair
Week 39 · Seachtain 39

25 Monday · Luan

26 Tuesday · Máirt

27 Wednesday · Céadaoin

28 Thursday · Déardaoin

29 Friday · Aoine

30 Saturday · Satharn

1 Sunday · Domhnach **October · Deireadh Fómhair**

Sarah Purser, *Portrait of George W. Russell (AE) (1867–1935), Poet, Artist and Economist,* **c.1902**

Russell was a mystic, poet, painter, journalist, economist and nationalist. Known by his pen-name, AE, or more correctly, Æ, signifying the lifelong quest of man, he was a member of the Irish Literary Revival and the Theosophical Society. As administrator of The Irish Agricultural Organisation Society, and editor of its newspaper, *The Irish Homestead,* he published Purser's work in this journal, giving her nationwide exposure. In spring 1902 Russell received paints from Purser, and later that year sat for her, at age 35. Purser captures Æ gazing past the viewer with an intent expression, mid-conversation, lower lip suggesting his characteristic 'chapters' of talk.

M	T	W	T	F	S	S
28	29	30	31	1	2	3
4	5	6	7	8	9	10
11	12	13	14	15	16	17
18	19	20	21	22	23	24
25	26	27	28	29	30	1

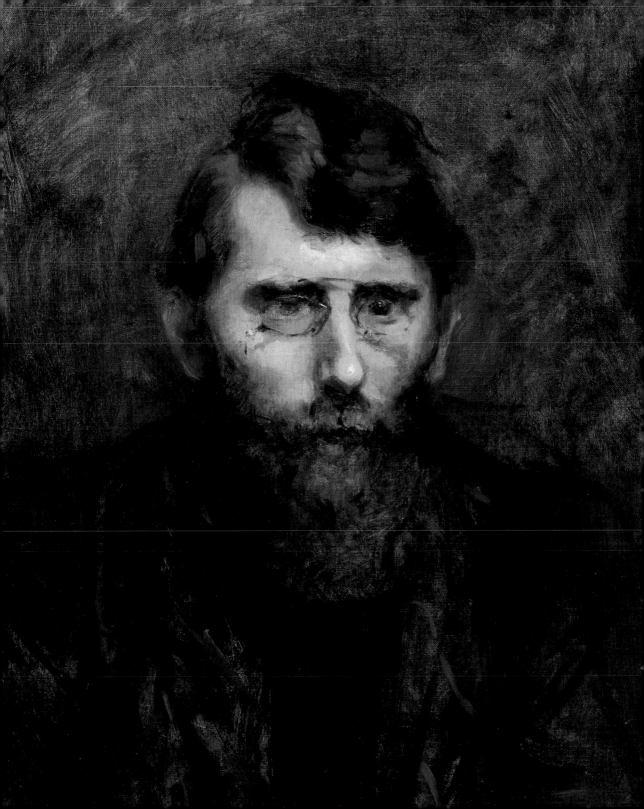

October • Deireadh Fómhair
Week 40 • Seachtain 40

2 Monday • Luan

3 Tuesday • Máirt

4 Wednesday • Céadaoin

5 Thursday • Déardaoin

6 Friday • Aoine

7 Saturday • Satharn

8 Sunday • Domhnach

Norah McGuinness, *The Startled Bird,* **1961**

This landscape is set in the woods on the south side of Carrickgollogan, South County Dublin, not far from the cottage and studio overlooking the Dublin Mountains to which the artist moved in 1957. McGuinness often painted woodland and shoreland scenes, incorporating figurative elements into her vividly coloured compositions. The presence of the little girl and blackbird lend this painting a narrative dimension that complements the landscape. McGuinness was consistently concerned with pattern making and the harmonious juxtaposition of colour, revealing Fauvist and Cubist influences. This painting typifies the synthesis of colour, form and subject that characterises her finest work.

M	T	W	T	F	S	S
25	26	27	28	29	30	1
2	3	4	5	6	7	8
9	10	11	12	13	14	15
16	17	18	19	20	21	22
23	24	25	26	27	28	29
30	31	1	2	3	4	5

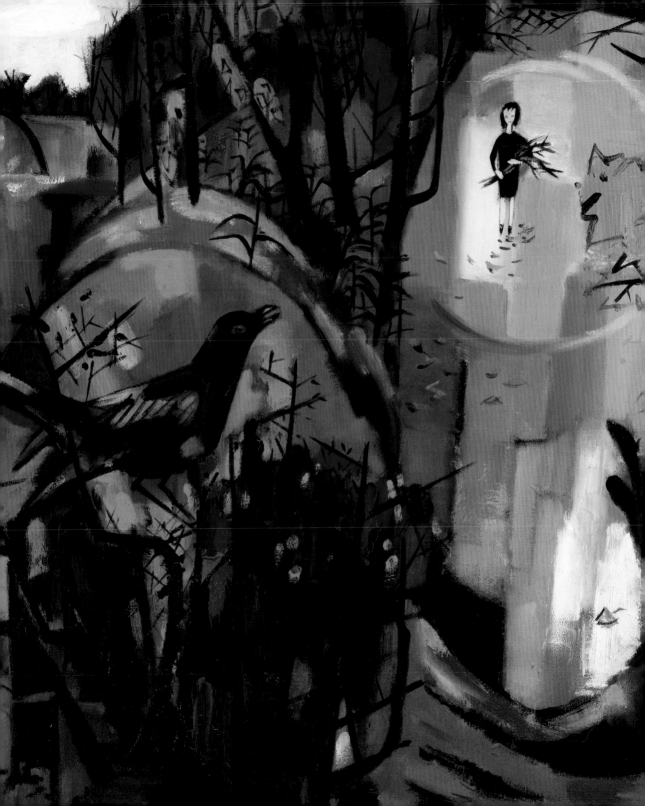

October · Deireadh Fómhair
Week 41 · Seachtain 41

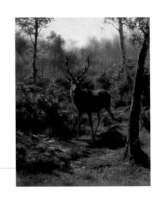

9 Monday · Luan

10 Tuesday · Máirt

11 Wednesday · Céadaoin

12 Thursday · Déardaoin

13 Friday · Aoine

14 Saturday · Satharn

15 Sunday · Domhnach

Rosa Bonheur, *A Stag,* **1893**

Bonheur was one of the finest *animaliers* (animal painters) of the 19th century, and the first woman artist to receive the French *Legion d'honneur*. In 1860 she purchased the Château de By near Fontainebleau, set in acres of pasture and woodlands. She built up a menagerie including gazelles, deer, elk, bulls, goats and a yak, which roamed on her land. Bonheur cared deeply for her animals and worried that she deprived them of their liberty. This stag dates from late in her career, when she remained close to her animals, painting them from life on misty mornings on her estate.

M	T	W	T	F	S	S
25	26	27	28	29	30	1
2	3	4	5	6	7	8
9	10	11	12	13	14	15
16	17	18	19	20	21	22
23	24	25	26	27	28	29
30	31	1	2	3	4	5

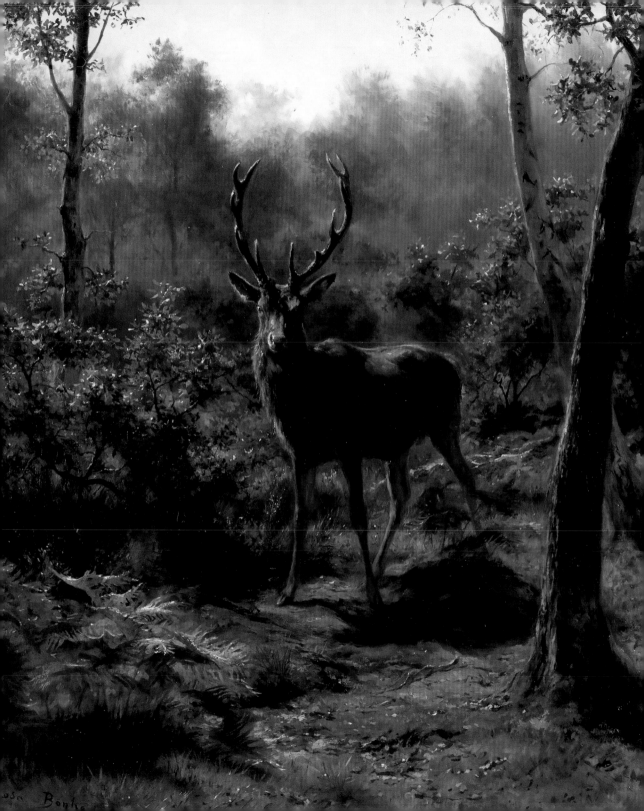

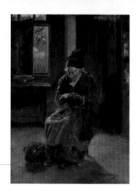

16 Monday · Luan

17 Tuesday · Máirt

18 Wednesday · Céadaoin

19 Thursday · Déardaoin

20 Friday · Aoine

21 Saturday · Satharn

22 Sunday · Domhnach

Helen Mabel Trevor, *Interior of a Breton Cottage,* **1892**

Helen Mabel Trevor was born in County Down and studied art in London and Paris. She was a frequent visitor to Brittany in the 1880s and 1890s, becoming known for her scenes of Breton women in their homes, which she painted with an increasingly strong sense of realism. Here, Trevor depicts the sparsely furnished interior of a cottage where an old woman is absorbed in her daily task of peeling potatoes. The humble subject matter is captured in thin brushstrokes of predominantly brown tones, relieved only by the shaft of light entering through partially opened shutters.

M	T	W	T	F	S	S
25	26	27	28	29	30	1
2	3	4	5	6	7	8
9	10	11	12	13	14	15
16	17	18	19	20	21	22
23	24	25	26	27	28	29
30	31	1	2	3	4	5

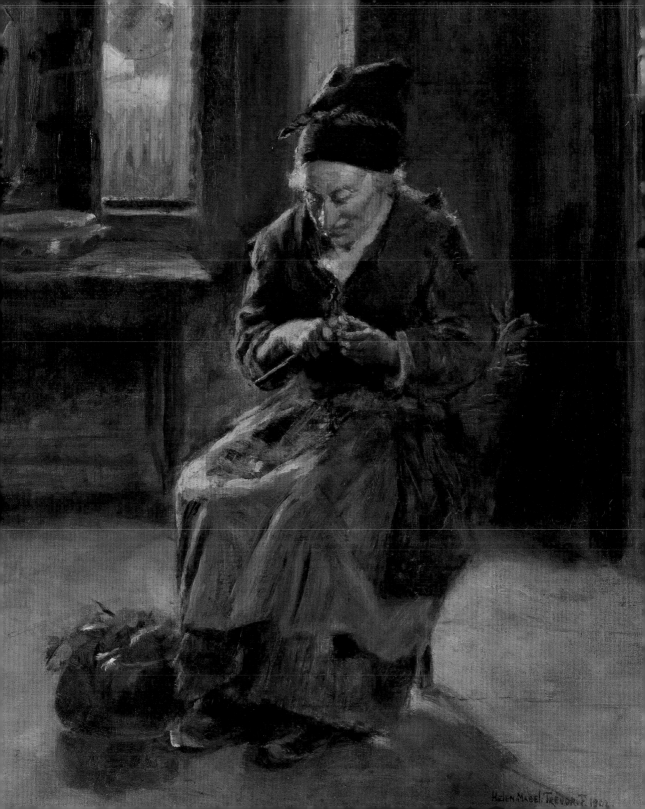

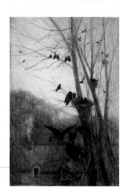

23 Monday · Luan

24 Tuesday · Máirt

25 Wednesday · Céadaoin

26 Thursday · Déardaoin

27 Friday · Aoine

28 Saturday · Satharn

29 Sunday · Domhnach

MIldred Anne Butler, *Shades of Evening,* **1904**

While studying in Cornwall in the 1890s, Butler was introduced to animal painting, which became her forte. The garden of her home at Kilmurry, County Kilkenny, was noted for its profusion of birdlife, particularly crows, jackdaws and pigeons. Butler's best-known bird subjects are groups, or clamours, of rooks, which congregated in the trees around her house, as seen here. This evocative picture captures the tranquillity of evening as the birds return to their nests before nightfall.

M	T	W	T	F	S	S
25	26	27	28	29	30	1
2	3	4	5	6	7	8
9	10	11	12	13	14	15
16	17	18	19	20	21	22
23	24	25	26	27	28	29
30	31	1	2	3	4	5

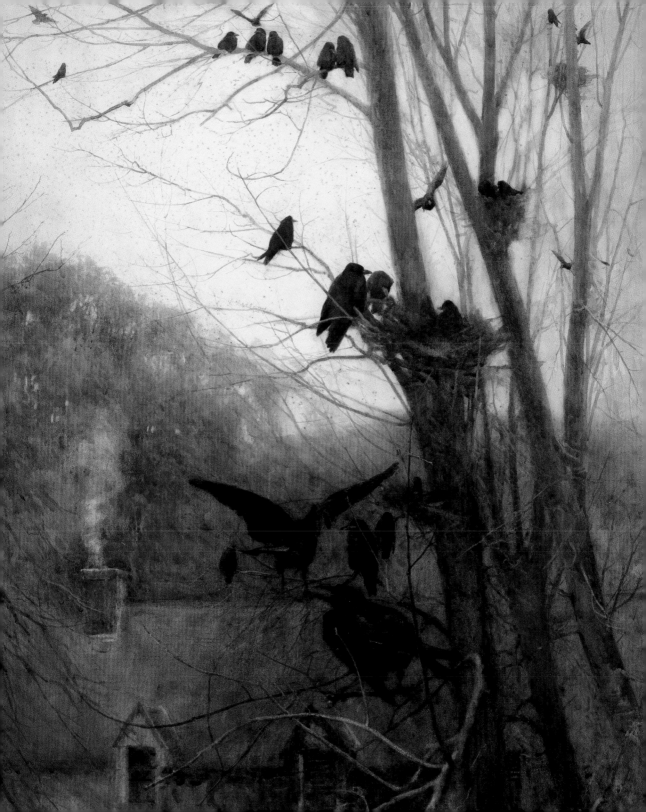

October · Deireadh Fómhair
Week 44 · Seachtain 44

30 Monday · Luan
Bank Holiday (RoI)

31 Tuesday · Máirt

1 Wednesday · Céadaoin

November · Samhain

2 Thursday · Déardaoin

3 Friday · Aoine

4 Saturday · Satharn

5 Sunday · Domhnach

Sarah Purser, *Roger Casement (1864–1916), Patriot and Revolutionary,* **c.1913**

Sarah Purser painted several Irish politicians and patriots including the revolutionary Roger Casement (1864–1916). This preparatory sketch for a more formal portrait possesses a vitality evident in the sitter's lips, which are parted as if in mid-conversation with the artist, with whom he makes eye contact. In 1914 Roger Casement travelled to Germany seeking military aid for the Irish republican movement. On his return he attempted to postpone the Easter Rising, but was arrested and hanged in England in 1916.

M	T	W	T	F	S	S
25	26	27	28	29	30	1
2	3	4	5	6	7	8
9	10	11	12	13	14	15
16	17	18	19	20	21	22
23	24	25	26	27	28	29
30	31	1	2	3	4	5

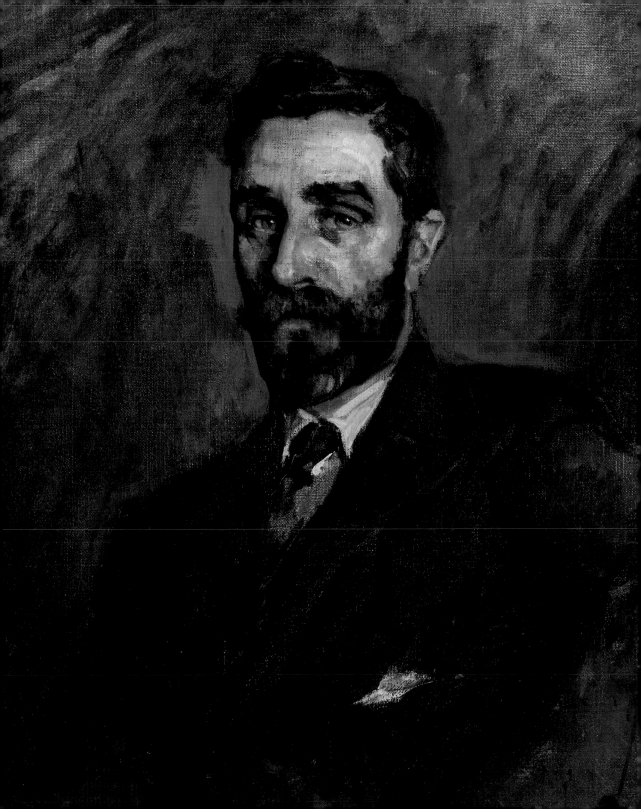

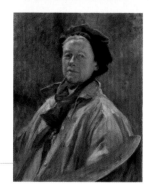

6 Monday · Luan

7 Tuesday · Máirt

8 Wednesday · Céadaoin

9 Thursday · Déardaoin

10 Friday · Aoine

11 Saturday · Satharn

12 Sunday · Domhnach

Helen Mabel Trevor, *Self-Portrait,* **1890s**

Trevor only took up painting professionally in her late 40s after her father's death. She studied in London and Paris, and made prolonged visits to Italy and Brittany before settling in Paris. This self-portrait probably dates from the 1890s when she was in her 60s and living in that city. Trevor depicts herself honestly, as a mature painter at the height of her powers, complete with artist's cap, smock and palette. The looseness of her brushstrokes conveys her confidence at this stage in her career.

M	T	W	T	F	S	S
30	31	1	2	3	4	5
6	7	8	9	10	11	12
13	14	15	16	17	18	19
20	21	22	23	24	25	26
27	28	29	30	1	2	3

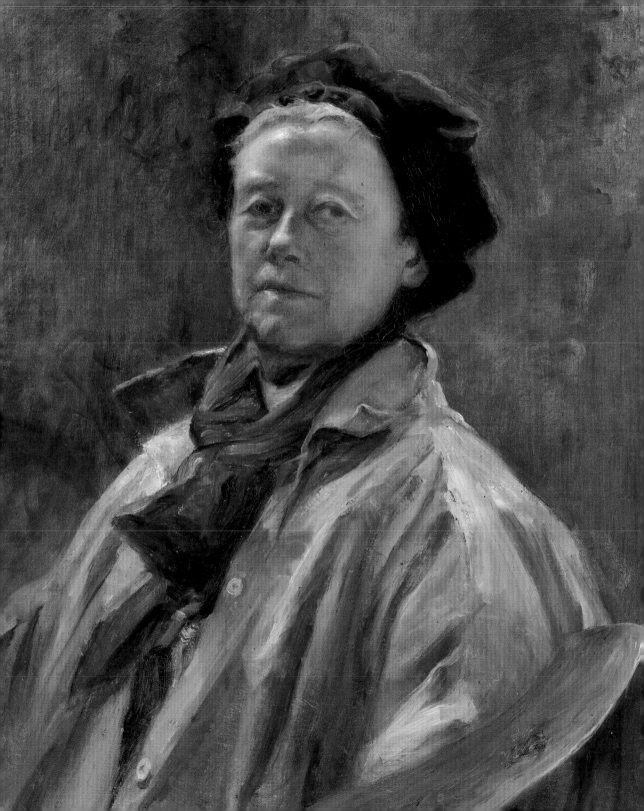

November · Samhain
Week 46 · Seachtain 46

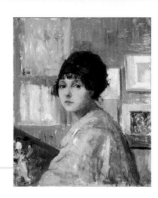

13 Monday · Luan

14 Tuesday · Máirt

15 Wednesday · Céadaoin

16 Thursday · Déardaoin

17 Friday · Aoine

18 Saturday · Satharn

19 Sunday · Domhnach

Moyra Barry, *Self-Portrait in the Artist's Studio,* **1920**

Moyra Barry trained in Dublin and London and taught painting and English at Quito in Equador in the late 1920s. She specialised in flower pieces in oil and watercolour, also painting still life, landscapes, genre and portraits. In this spirited self-portrait, Barry adopts a serene, somewhat quizzical expression as she looks up from her palette. She wears a black scarf tied in a flat bow high on her short hairstyle, which was highly fashionable in 1920. Her delicate facial features are carefully recorded, while her artist's smock, palette and studio are painted with vigorous brushwork, showing the influence of Impressionism.

M	T	W	T	F	S	S
30	31	1	2	3	4	5
6	7	8	9	10	11	12
13	14	15	16	17	18	19
20	21	22	23	24	25	26
27	28	29	30	1	2	3

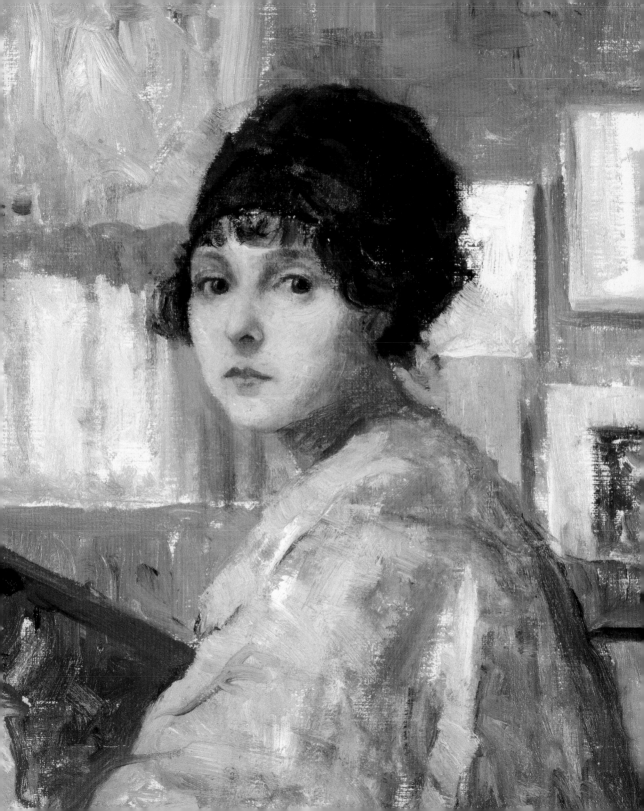

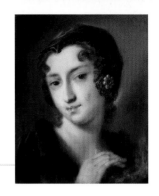

November · Samhain
Week 47 · Seachtain 47

20 Monday · Luan

21 Tuesday · Máirt

22 Wednesday · Céadaoin

23 Thursday · Déardaoin

24 Friday · Aoine

25 Saturday · Satharn

26 Sunday · Domhnach

Rosalba Carriera, *Winter,* **c.1740**

The Gallery's set of the four seasons by Carriera are identical in size, in elaborate, possibly Irish, gilt frames made in c.1750. Each young woman is drawn with her traditional seasonal attributes, her soft complexion conveyed by blending colours over the surface of the paper with the pastel stump. *Winter* wears a fur-collared blue velvet gown, which sets off her pale neck and shoulders. Her dark hair is partly covered by a blue velvet cap trimmed with black lace and a pearl and ruby ornament. The ruby is echoed in her lightly rouged lips and cheeks, emphasising her dark seductive eyes.

M	T	W	T	F	S	S
30	31	1	2	3	4	5
6	7	8	9	10	11	12
13	14	15	16	17	18	19
20	21	22	23	24	25	26
27	28	29	30	1	2	3

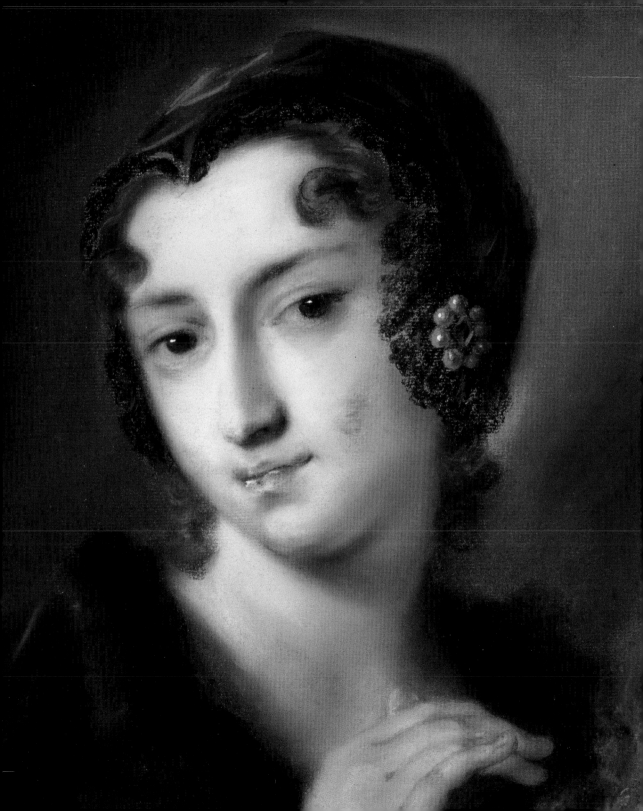

November · Samhain
Week 48 · Seachtain 48

27 Monday · Luan

28 Tuesday · Máirt

29 Wednesday · Céadaoin

30 Thursday · Déardaoin

1 Friday · Aoine **December · Nollaig**

2 Saturday · Satharn

3 Sunday · Domhnach

Angelica Kauffmann, *The Ely Family,* **1771**

Kauffman, a leading portrait painter of the later 18th century, visited Ireland in 1771, when she received a number of commissions including this one from the Ely family, with whom she stayed at Rathfarnham Castle. Charles Tottenham, 1st Marquess of Ely, appears beside his wife, and gestures towards his two nieces. The younger girl, Frances, plays a fashionable aria, *La Buona Figiuola*, from an opera by Niccolò Piccinni on the harpsichord, while her older sister Dolly Monroe, one of the beauties of her day, poses in classical costume.

M	T	W	T	F	S	S
30	31	1	2	3	4	5
6	7	8	9	10	11	12
13	14	15	16	17	18	19
20	21	22	23	24	25	26
27	28	29	30	1	2	3

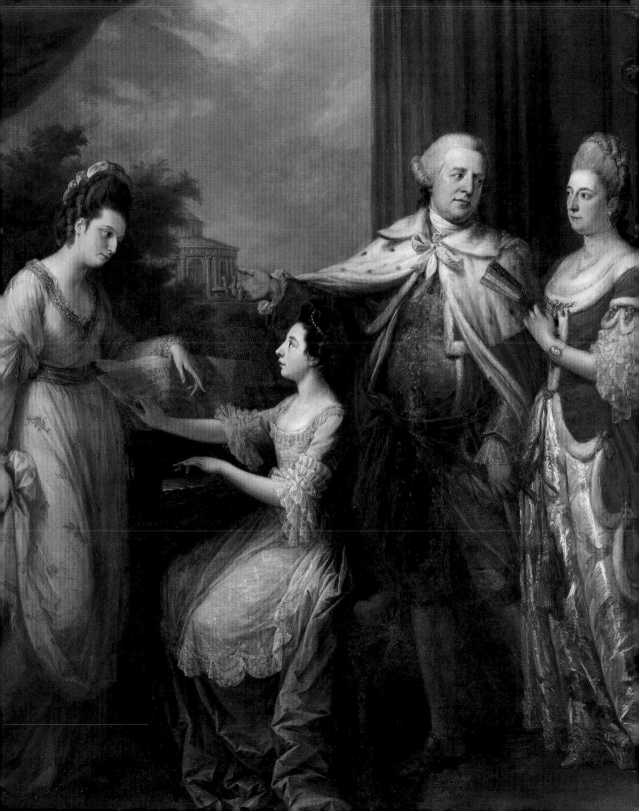

December · Nollaig
Week 49 · Seachtain 49

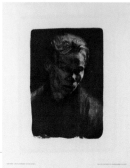

4 Monday · Luan

5 Tuesday · Máirt

6 Wednesday · Céadaoin

7 Thursday · Déardaoin

8 Friday · Aoine

9 Saturday · Satharn

10 Sunday · Domhnach

Käthe Kollwitz, *Working Woman with Blue Shawl,* **1903**

German artist Kollwitz saw the potential of the lithographic print for making social commentary. Her print cycles, including *A Weavers' Revolt and Peasants' War,* evoked the abhorrent conditions of modern industrial labour. The woman in this lithograph is most likely one of her doctor husband's working-class patients, whom she often used as models. This print was purchased by the National Gallery along with a deeply honest self-portrait, created when the artist was aged 60. Both works exemplify the intensely introspective, highly realist and deeply compassionate images which Kollwitz created of careworn faces, revealing the suffering experienced by women, including herself.

M	T	W	T	F	S	S
27	28	29	30	1	2	3
4	5	6	7	8	9	10
11	12	13	14	15	16	17
18	19	20	21	22	23	24
25	26	27	28	29	30	31

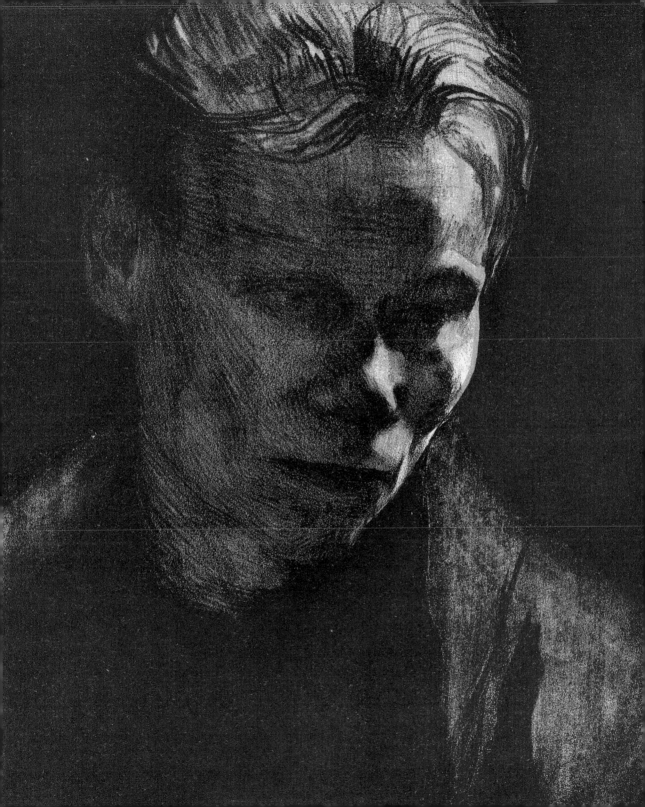

December • Nollaig
Week 50 • Seachtain 50

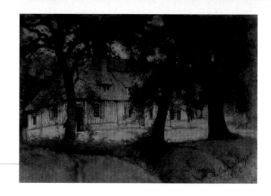

11 Monday • Luan

12 Tuesday • Máirt

13 Wednesday • Céadaoin

14 Thursday • Déardaoin

15 Friday • Aoine

16 Saturday • Satharn

17 Sunday • Domhnach

Harriet Osborne O'Hagan, *A Farm in Normandy,* **1880**

O'Hagan was almost 40 when she travelled from Dublin to Paris in the 1860s to further her studies. She trained under Thomas Couture, probably attending his summer courses for women at Villiers-le-Bel in the 1870s, and visiting Normandy in 1880. The tall roof and timber-beamed façade of this house, viewed through trees, are characteristic of Normandy farmhouses. A small figure can be glimpsed just inside the doorway. O'Hagan's drawing style resembled Couture's, while her use of cross-hatching recalls Jean-François Millet's charcoal technique. She enjoyed using soft charcoal, in this drawing rubbed against the grain of the paper to great effect.

M	T	W	T	F	S	S
27	28	29	30	1	2	3
4	5	6	7	8	9	10
11	12	13	14	15	16	17
18	19	20	21	22	23	24
25	26	27	28	29	30	31

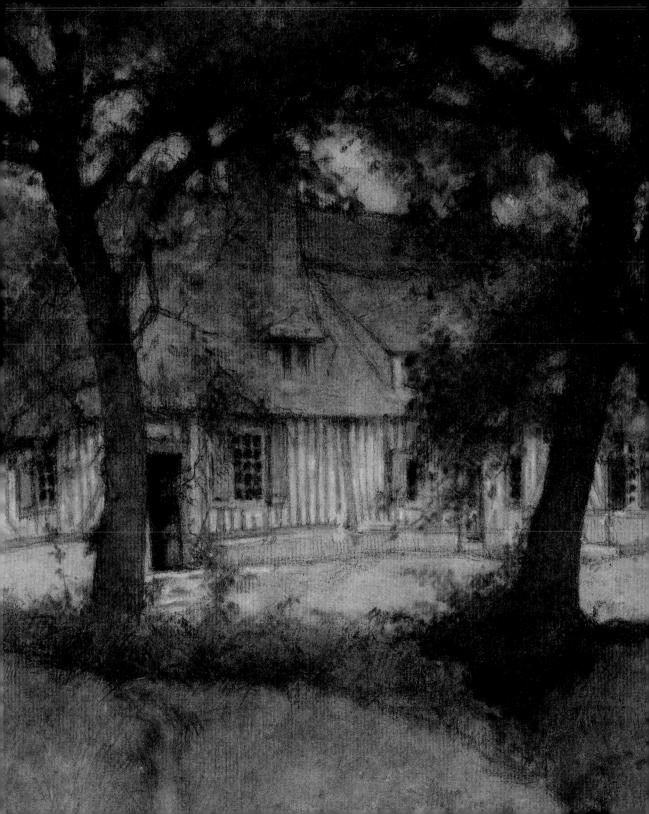

December • Nollaig
Week 51 • Seachtain 51

18 Monday • Luan

19 Tuesday • Máirt

20 Wednesday • Céadaoin

21 Thursday • Déardaoin

22 Friday • Aoine

23 Saturday • Satharn

24 Sunday • Domhnach
Christmas Eve

Alicia Boyle, *Winter Planes,* **1960**

Born in Bangkok to Irish parents, Boyle grew up in Limavaddy, County Derry. She moved to London in 1920, where she won a scholarship to the Byam Shaw School of Art. For much of her life Boyle supported herself by teaching art part-time, which allowed her to continue painting and to travel in Europe, including to Greece and Spain. During the 1960s, when this work was painted, Boyle made regular trips to County Cork, establishing a studio near Durrus, West Cork, in 1971. She lived there for several years until she settled in Monkstown, County Dublin, continuing to paint until her death.

M	T	W	T	F	S	S
27	28	29	30	1	2	3
4	5	6	7	8	9	10
11	12	13	14	15	16	17
18	19	20	21	22	23	24
25	26	27	28	29	30	31

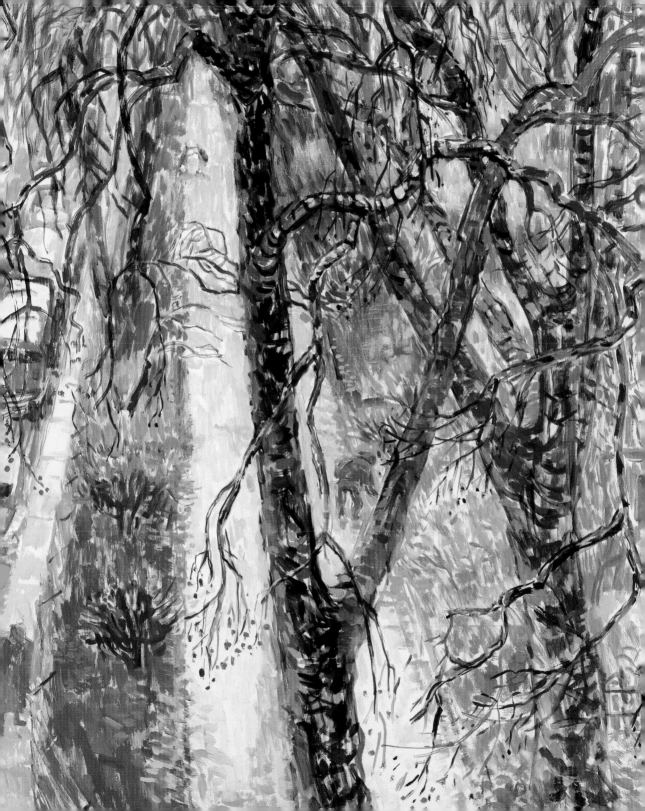

25 Monday · Luan

Christmas Day

26 Tuesday · Máirt

St Stephen's Day

27 Wednesday · Céadaoin

28 Thursday · Déardaoin

29 Friday · Aoine

30 Saturday · Satharn

31 Sunday · Domhnach

New Year's Eve

Mainie Jellett, *The Virgin and Child Enthroned,* **20th century**

Having studied Cubism in Paris with teachers André Lhote and Albert Gleizes, Jellett became a pioneer of abstract art in Ireland, along with her close friend Evie Hone. Their importance for the development of modern art in Ireland cannot be overemphasised. They held their first joint exhibition in 1924 at the Dublin Painters' Gallery, showing abstract and cubist works, which met with misunderstanding and derision from the public. Unperturbed, Jellett dedicated her career to educating Ireland about modernism and painting in an abstract or semi-abstract mode, her late works showing a return to figurative, vividly coloured and often religious themes.

M	T	W	T	F	S	S
27	28	29	30	1	2	3
4	5	6	7	8	9	10
11	12	13	14	15	16	17
18	19	20	21	22	23	24
25	26	27	28	29	30	31

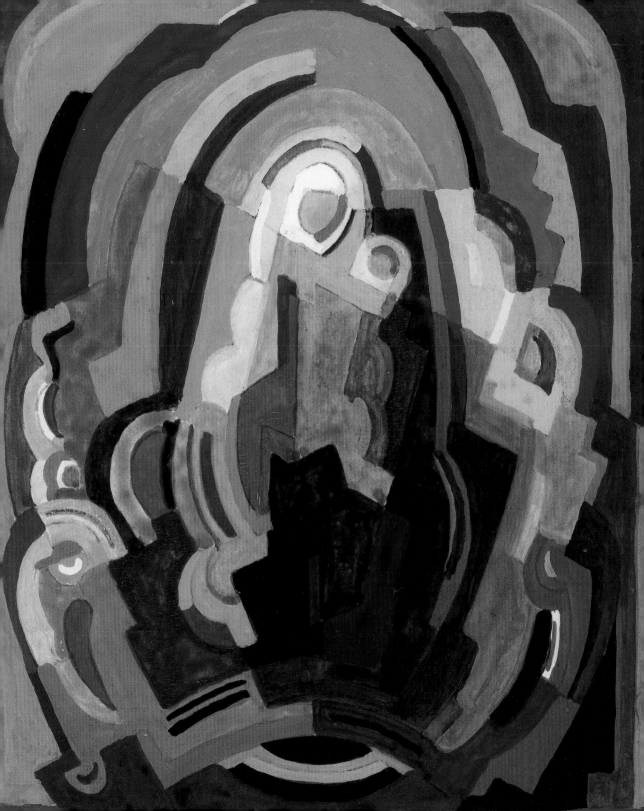

List of Works

Charlotte Edgeworth, Irish, 19th C, *Elizabeth McCausland, 1896–1807,* 1807, Watercolour on ivory, 6.8 x 5.3 cm, NGI.7550

Clare Marsh, Irish, 1875–1923, *Sketch of Trees,* Oil on card, 25.5 x 19 cm, NGI.4690

Helen Mabel Trevor, Irish, 1831–1900, *The Fisherman's Mother,* 1892, Oil on canvas, 65 x 53 cm, NGI.500

Louise Catherine Breslau, Swiss, 1856–1927, *Berligot Ibsen (née Bjørnsen),* 1889, Oil on canvas, 131 x 90 cm, NGI.908

Sarah Henrietta Purser, Irish, 1848–1943, *A Lady Holding a Rattle,* 1885, Oil on canvas, 41 x 31 cm, NGI.4131

Harriet Osborne O'Hagan, Irish, 1830–1921, *An Interior,* late 19th C, Oil on panel, 46 x 37 cm, NGI.1174

Jane O'Malley, Canadian, 1944–, *Still Life, La Geria,* 2013, Carborundum, Sheet: 38.3 x 45.8 cm, Plate: 27.6 x 37.2 cm, NGI.2017.21.3, © Jane O'Malley.

Dod Procter, British, 1890–1972, *Sleeping Girl,* c.1927, Oil on canvas, 61 x 58 cm, NGI.1294, © The Estate of Dod Procter / Bridgeman Images.

Alice Neel, American, 1900–1984, *Cityscape,* 1934, Oil on canvas, NGI.2018.10, © The Estate of Alice Neel.

Rosalba Carriera, Italian, 1675–1757, *Spring,* Pastel on blue paper, 33.9 x 27.3 cm, NGI.3846

Lavinia Fontana, Italian, 1552–1614, *Portrait of a Gentleman in Armour,* late 1590s, Oil on canvas, 89 x 65 cm, NGI.460

Elizabeth Rivers, British, 1903–1964, *Star in the East,* c.1960, Wood engraving in blue ink on paper, 18 x 12 cm, NGI.2011.10, © The Estate of Elizabeth Rivers.

Sarah Henrietta Purser, Irish, 1848–1943, *Le Petit Déjeuner,* 1881, Oil on canvas, 35 x 27 cm, NGI.1424

Mainie Jellett, Irish, 1897–1944, *Achill Horses,* 1941, Oil on canvas, 61 x 92 cm, NGI.4320

Margaret Clarke, Irish, 1884–1961, *St Patrick with a Group of Figures and an Irish Wolfhound,* Watercolour, gouache, charcoal and graphite on paper, 38.1 x 26.8 cm, NGI.2007.56, © The Artist's Estate.

Mary Swanzy, Irish, 1882–1978, *Self-Portrait with a Candle,* c.1940, Oil on board, 32.5 x 25 cm, NGI.4699, © The Artist's Estate.

Angelica Kauffmann, Swiss, 1741–1807, *Portrait of Mrs Helen (Dorothea Daniel) (d.1806),* Oil on canvas, 76 x 63 cm, NGI.888

Mary Swanzy, Irish, 1882–1978, *A Landscape,* Oil on canvas, 56 x 64 cm, NGI.1300, © The Artist's Estate.

Margaret Clarke, Irish, 1884–1961, *Ophelia,* c.1926, Oil on panel, 39 x 61 cm, NGI.4679, © The Artist's Estate.

Elizabeth Yeats, Irish, 1868–1940, *Hand-painted Fan,* 1905, NGI.YA/Y19

Lavinia Fontana, Italian, 1552–1614, *The Visit of the Queen of Sheba to King Solomon,* c.1600, 256 x 325 cm, NGI.76

Muriel Brandt, Irish, 1909–1981, *Christine, Countess of Longford,* Oil on canvas, 53 x 76 cm, NGI.1781, © Reserved National Gallery of Ireland.

Sarah Paxton Ball Dodson, American, 1847–1906, *Mayfield Convent,* 19th C, Oil on canvas, 35.5 x 44.5 cm, NGI.4000

Sarah Henrietta Purser, Irish, 1848–1943, *Mrs Moore, 24 Powers Court,* Charcoal, bodycolour (white highlights) on buff laid coloured paper, 46.4 x 34 cm, NGI.2009.3

Maria Spilsbury Taylor, British, 1776–1820, *Patron's Day at the Seven Churches, Glendalough,* c.1816, Oil on canvas, 106.5 x 128.5 cm, NGI.458

Eva Gonzalès, French, 1849–1883, *Children on the Sand Dunes, Grandcamp,* 1877–1878, Oil on canvas, 46 x 56 cm, NGI.4050

Mildred Anne Butler, Irish, 1858–1941, *The Lilac Phlox, Kilmurry, County Kilkenny,* 1912, Watercolour on paper, 36.1 x 54 cm, NGI.7954

Mary Swanzy, Irish, 1882–1978, *Allegory,* c.1945–1949, Oil on canvas, 63.5 x 71.1 cm, NGI.4720, © The Artist's Estate.

Rosalba Carriera, Italian, 1675–1757, *Summer,* Pastel on dark grey paper, 35 x 28 cm, NGI.3847

Taffina Flood, Irish, 1967–, *Winter Garden,* 1998, Carborundum and dry point on Hahnemuhle paper, Sheet: 50 x 56.5 cm, Image: 36.8 x 45.5 cm, NGI.20872, © Taffina Flood.

Letitia Marion Hamilton, Irish, 1878–1964, *Bantry Bay with a Sailing Boat Seen Through Woodland,* c.1940s, Oil on canvas, 50 x 60 cm, NGI.4669, © Reserved National Gallery of Ireland.

Frances 'Fanny' Wilmot Currey, Irish, 1848–1917, *Woman Washing Clothes by a River,* 1879, Watercolour on board, 27 x 18.5 cm, NGI.2010.9

Berthe Morisot, French, 1841–1895, *Le Corsage Noir,* 1878, Oil on canvas, 73 x 65 cm, NGI.984

Mainie Jellett, Irish, 1897–1944, *Nudes Dancing Round a Fountain by Moonlight,* c.1914, Oil on canvas, 88 x 63 cm, NGI.4334

Sofonisba Anguissola, Italian, c.1532–1625, *Portrait of Prince Alessandro Farnese (1545–1592), later Duke of Parma and Piacenza,* c.1560, Oil on canvas, 107 x 79 cm, NGI.17

Estella Frances Solomons, Irish, 1882–1968, *A View of Rosapenna from Breaghy Head,* 1931, Oil on canvas, 23 x 35 cm, NGI.1413, © Reserved National Gallery of Ireland.

Evie Hone, Irish, 1894–1955, *A Landscape with a Tree,* 1943, Oil on board, 69 x 69 cm, NGI.4322, © The Artist's Estate / Reserved National Gallery of Ireland.

Hilda Geralda van Stockum, Dutch, 1908–2006, *Portrait of Evie Hone (1894–1955),* Oil on canvas, 79 x 51 cm, NGI.4204, Image copyright © by the Estate of Hilda van Stockum, used by permission.

Julia Margaret Cameron, British, 1815–1879, *After the Manner of Perugino (Mary Ryan),* c.1865, Albumen print, Image: 20 x 11 cm, NGI.2018.55

Anne Yeats, Irish, 1919–2001, *The Breaking Net,* Oil, Framed: 70.2 x 90.6 x 6.5 cm, NGI.4725, © Estate of Anne Yeats, IVARO Dublin, 2022.

Sarah Henrietta Purser, Irish, 1848–1943, *Portrait of George W. Russell (AE) (1867–1935), Poet, Artist and Economist,* Oil on canvas, 68 x 51 cm, NGI.1024

Norah McGuinness, Irish, 1901–1980, *The Startled Bird,* 1961, Oil on canvas, 68.5 x 81.3 cm, NGI.2017.9, © National Library of Ireland.

Rosa Bonheur, French, 1822–1899, *A Stag,* 1893, Oil on canvas, 46 x 38 cm, NGI.4211

Helen Mabel Trevor, Irish, 1831–1900, *An Interior of a Breton Cottage,* 1892, Oil on canvas, 63 x 46 cm, NGI.501

Mildred Anne Butler, Irish, 1858–1941, *Shades of Evening,* 1904, Watercolour on paper, 97.5 x 65 cm, NGI.7953

Sarah Henrietta Purser, Irish, 1848–1943, *Roger Casement (1864–1916), Patriot and Revolutionary,* Oil on canvas, 102 x 76 cm, NGI.938

Helen Mabel Trevor, Irish, 1831–1900, *Self-Portrait,* 1890s, Oil on canvas, 66 x 55 cm, NGI.502

Moyra Barry, Irish, 1886–1960, *Self-Portrait in the Artist's Studio,* 1920, NGI.4366, © The Artist's Estate.

Rosalba Carriera, Italian, 1675–1757, *Winter,* c.1740, Pastel on blue paper, 34.2 x 27.7 cm, NGI.3849

Angelica Kauffmann, Swiss, 1741–1807, *The Ely Family,* 1771, Oil on canvas, 243 x 287 cm, NGI.200

Käthe Kollwitz, German, 1867–1945, *Working Woman with Blue Shawl,* 1903, Lithograph on paper, Sheet: 56 x 44.8 cm, NGI.2017.2

Harriet Osborne O'Hagan, Irish, 1830–1921, *A Farm in Normandy,* 1880, Charcoal and watercolour with white highlights on blue paper, 30.3 x 43.1 cm, NGI.3014

Alicia Boyle, Irish, 1908–1997, *Winter Planes,* 1960, Oil on canvas, 91.5 x 71 cm, NGI.4630, © The Artist's Estate.

Mainie Jellett, Irish, 1897–1944, *The Virgin and Child Enthroned,* Gouache on paper, 20.5 x 16.5 cm, NGI.7842

FRONT COVER, **Lavinia Fontana,** Italian, 1552–1614, *Isabella Ruini as Venus,* 1592, © Réunion des Musées Métropolitains Rouen Normandie, Musée des Beaux-Arts.

BACK COVER, **Mainie Jellett,** Irish, 1897–1944, *Abstract,* 1932, Gouache on paper, 60 x 35 cm, NGI.7845

ENDPAPERS, **Louisa Taylor,** British, 1855–1887, *The Taylor Family in their Living Room, Hung with Paintings,* 1858, Graphite on paper, 25.3 x 35.2 cm, NGI.2009.68

Image dimensions are unframed sizes.

All images: Photo © National Gallery of Ireland unless otherwise stated.

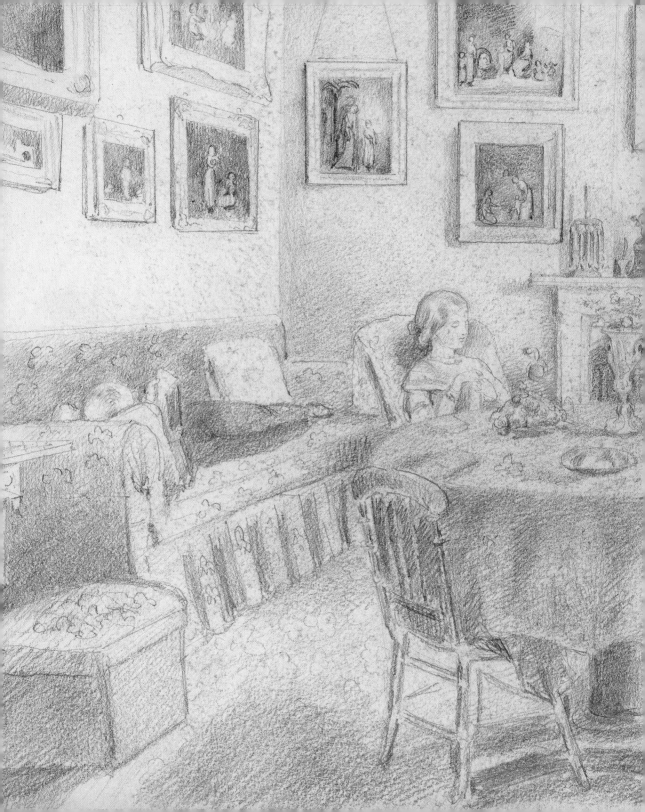